relaxing

THERAPY
AN ANTI-STRESS
COLORING
BOOK

RUNNING PRESS

PHILADELPHIA · LONDON

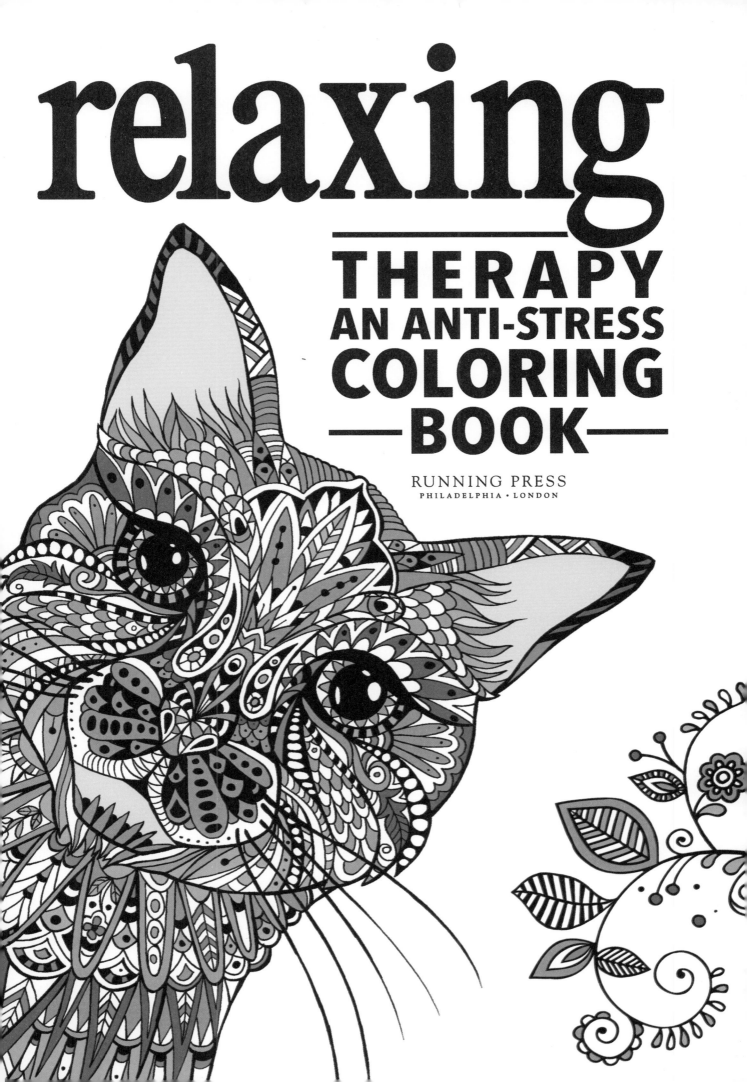

Illustrated by Chellie Carroll, Laura-Kate Chapman, Hannah Davies, Sam Loman, Richard Merritt, Lizzie Preston, and Cindy Wilde

Edited by Hannah Cohen
Cover design by John Bigwood
Designed by Jack Clucas

With additional material adapted from www.shutterstock.com

© 2016 by Michael O'Mara Books Limited

First published in the United States in 2016 by Running Press Book Publishers
A Member of the Perseus Books Group

Books published by Running Press are available at special discounts for bulk purchases in the United States by corporations, institutions, and other organizations. For more information, please contact the Special Markets Department at the Perseus Books Group, 2300 Chestnut Street, Suite 200, Philadelphia, PA 19103, or call (800) 810-4145, ext. 5000, or e-mail special.markets@perseusbooks.com.

ISBN 978-0-7624-6103-5
Library of Congress Control Number: 2015959424

9 8 7 6 5 4 3 2 1
Digit on the right indicates the number of this printing

Running Press Book Publishers
2300 Chestnut Street
Philadelphia, PA 19103-4371

Visit us on the web!
www.runningpress.com

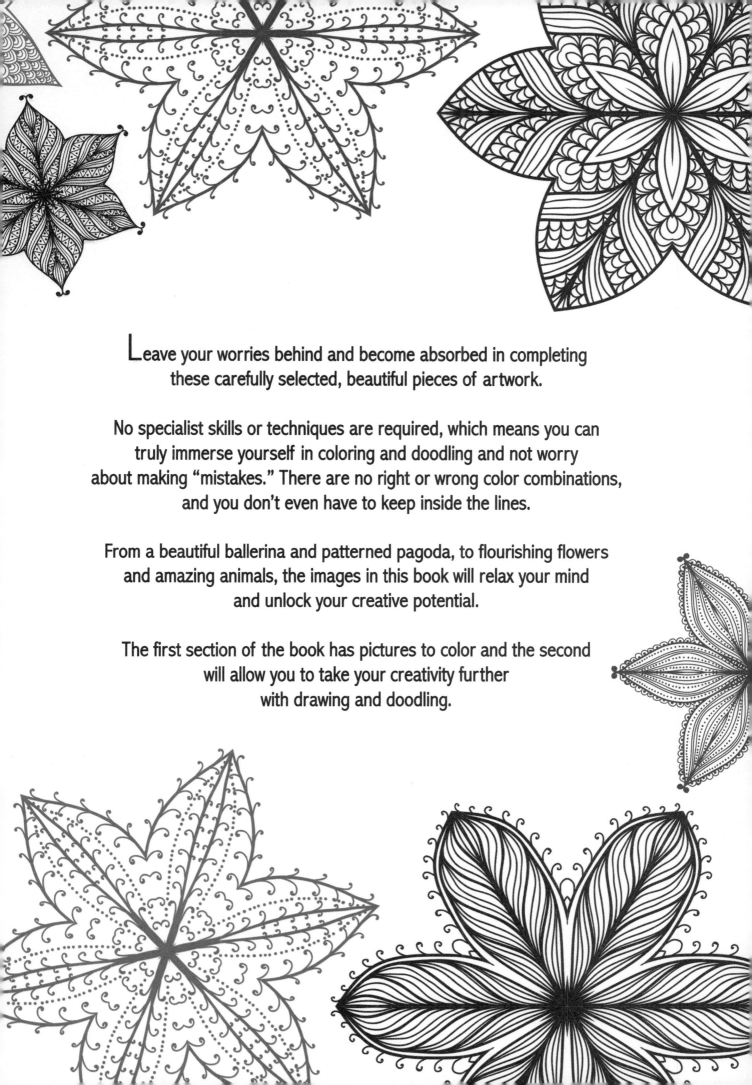

Leave your worries behind and become absorbed in completing
these carefully selected, beautiful pieces of artwork.

No specialist skills or techniques are required, which means you can
truly immerse yourself in coloring and doodling and not worry
about making "mistakes." There are no right or wrong color combinations,
and you don't even have to keep inside the lines.

From a beautiful ballerina and patterned pagoda, to flourishing flowers
and amazing animals, the images in this book will relax your mind
and unlock your creative potential.

The first section of the book has pictures to color and the second
will allow you to take your creativity further
with drawing and doodling.

COLORING

From delicate details to bold backgrounds, embark on a coloring journey and create beautiful images of your own. Pencils, pens, highlighters, and markers can all be used to bring the artwork to life.

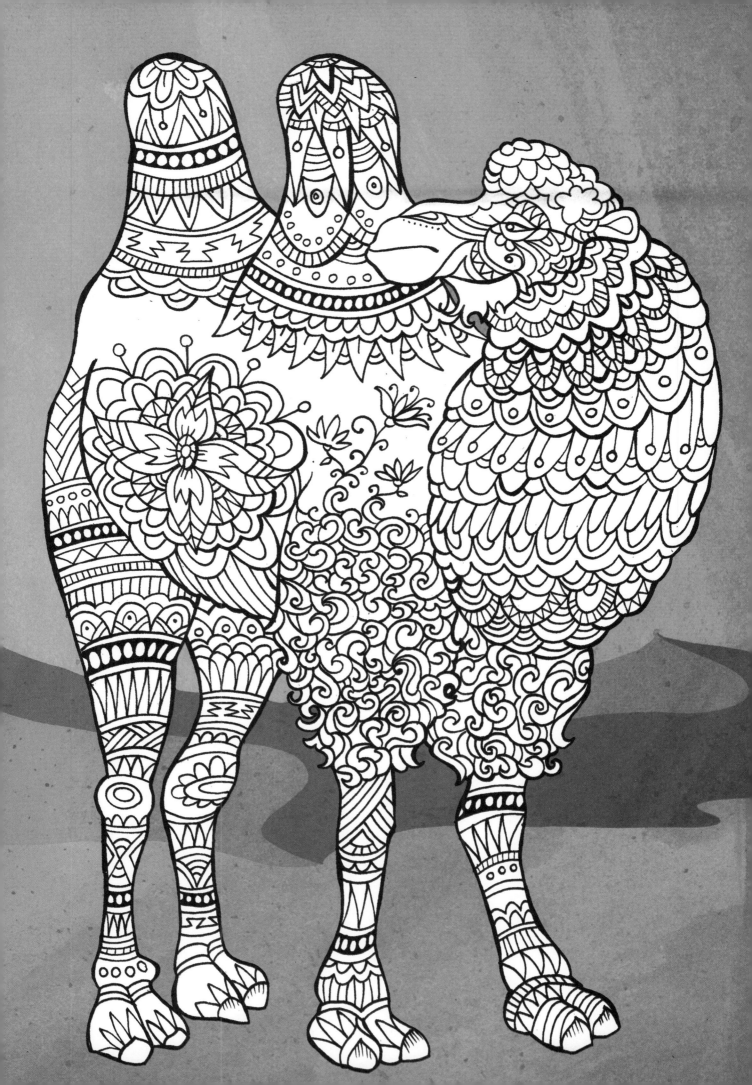

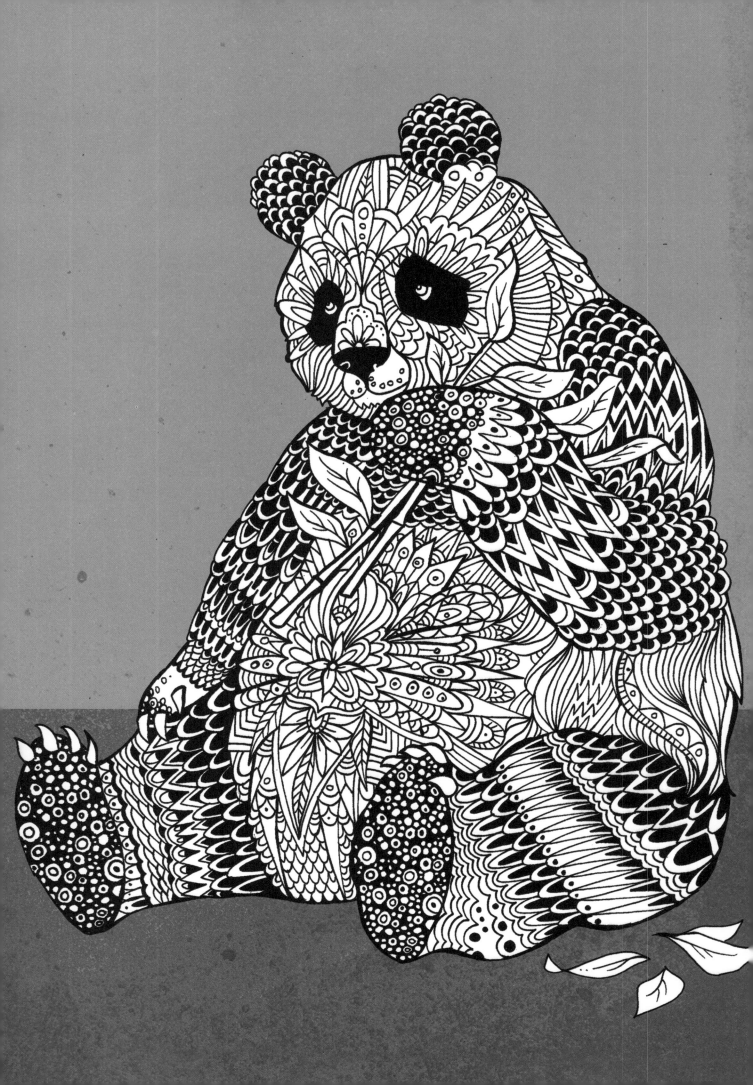

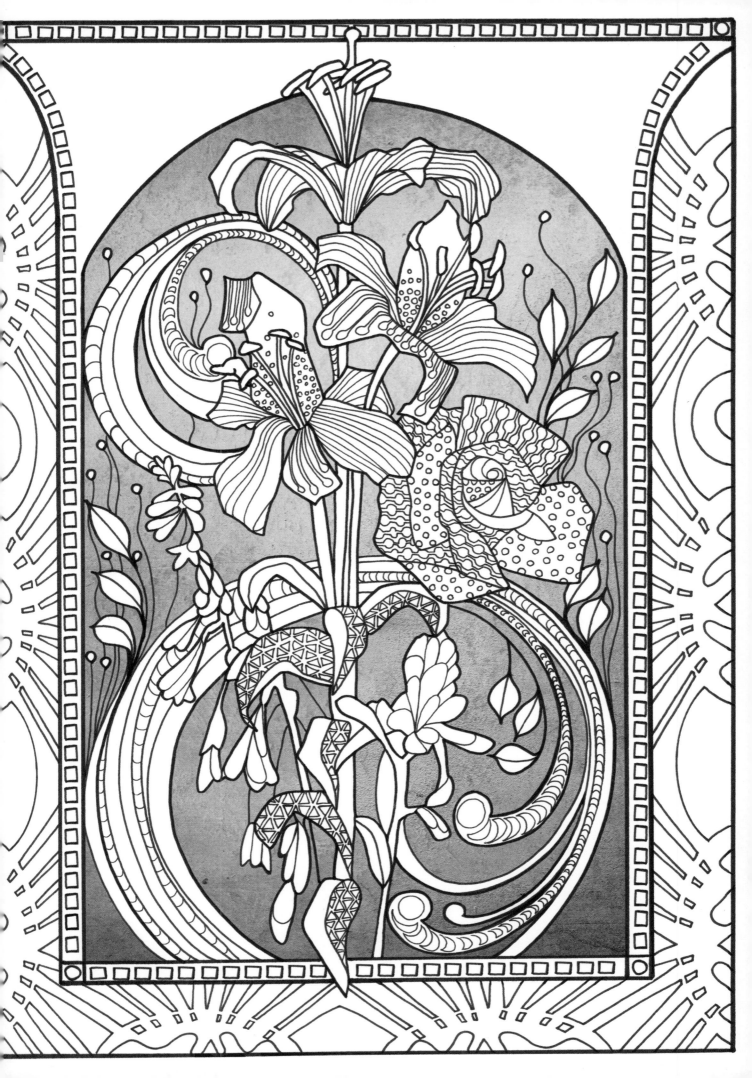

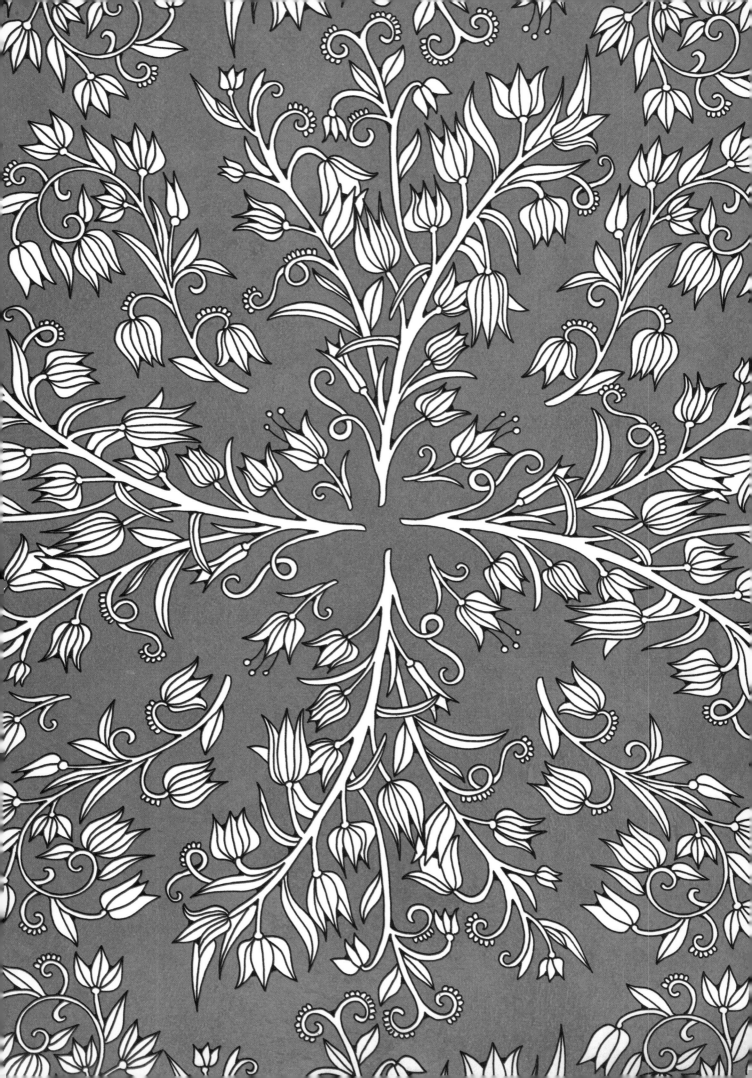

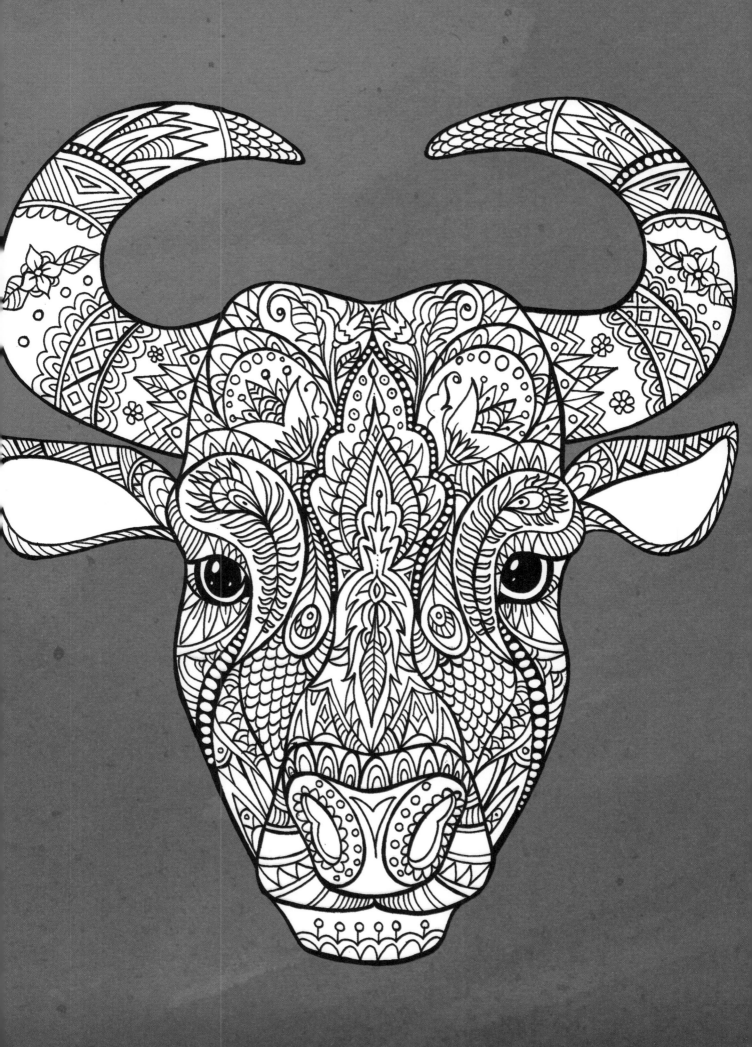

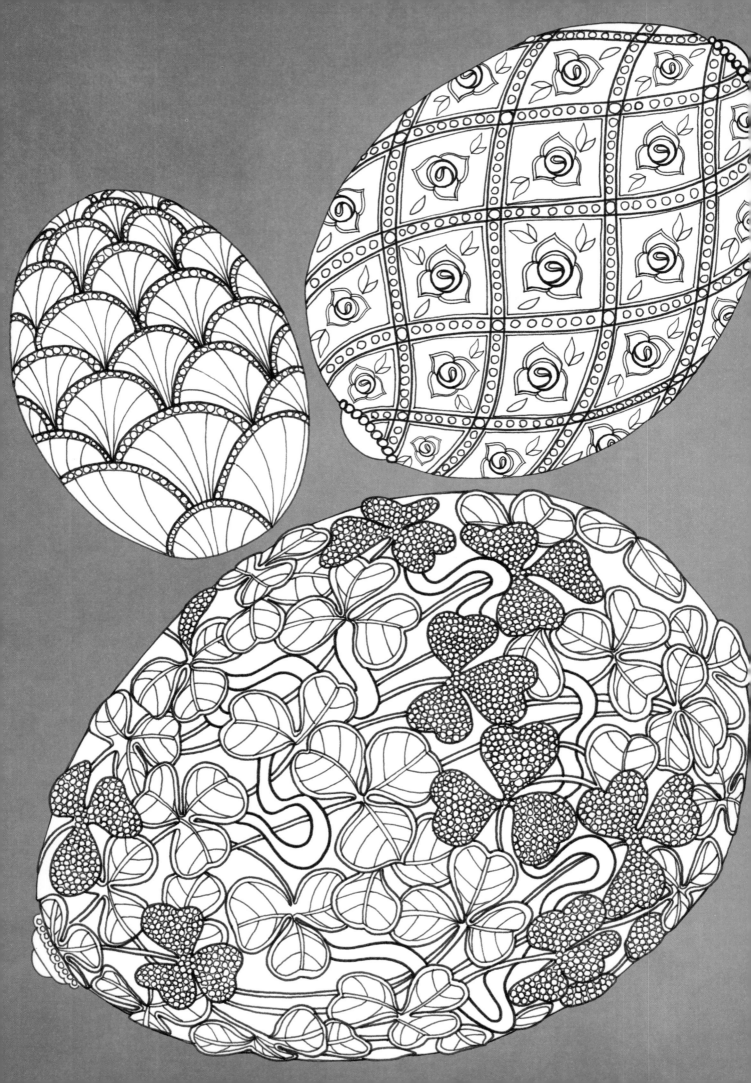

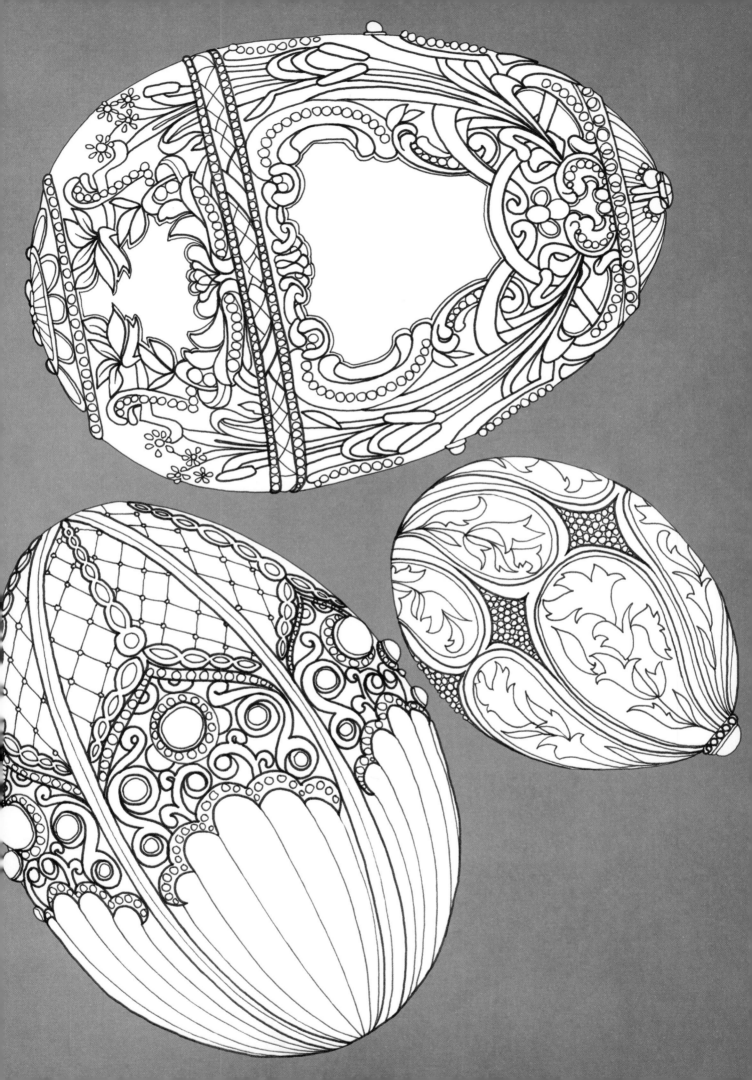

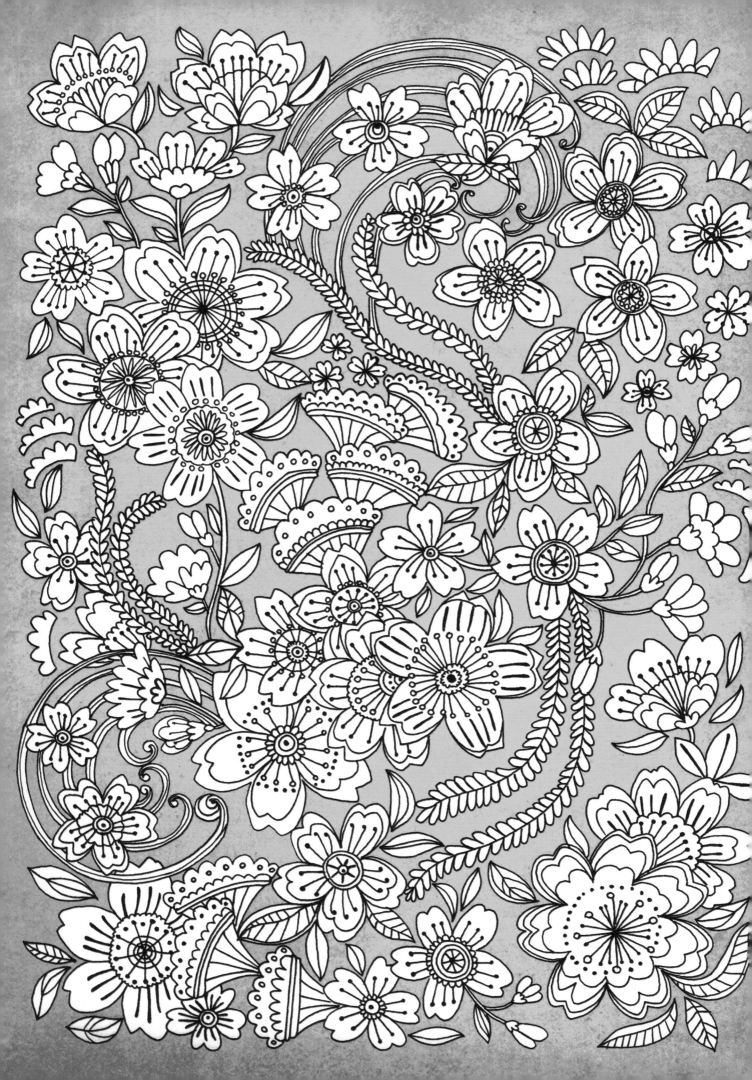

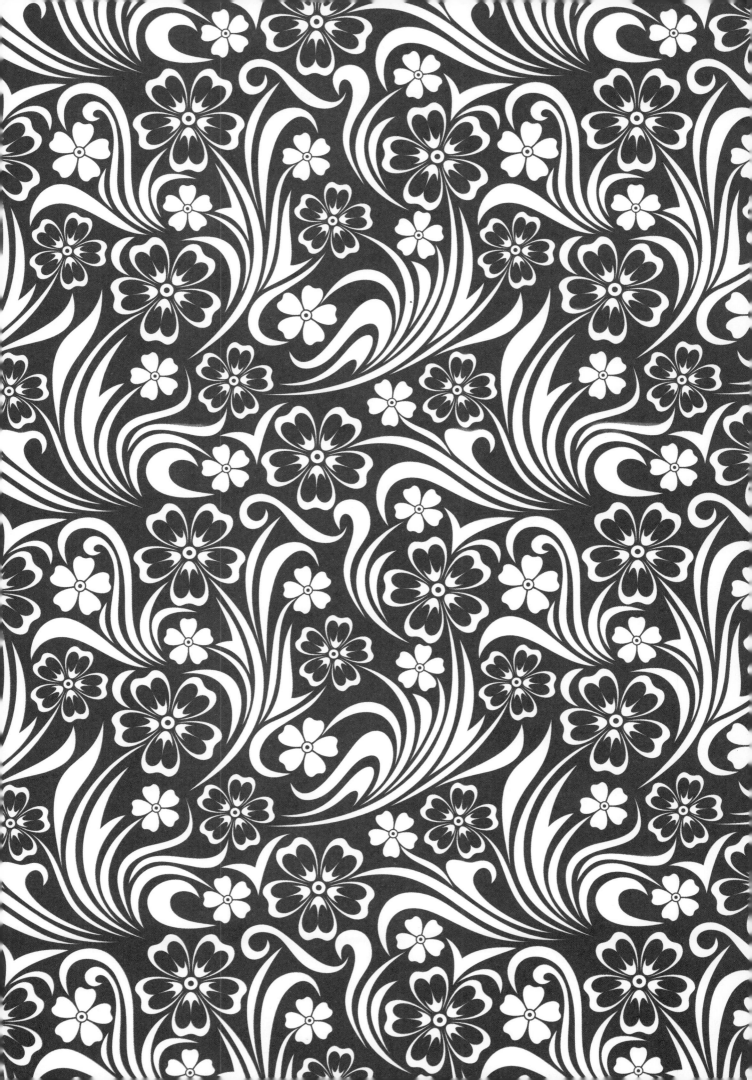

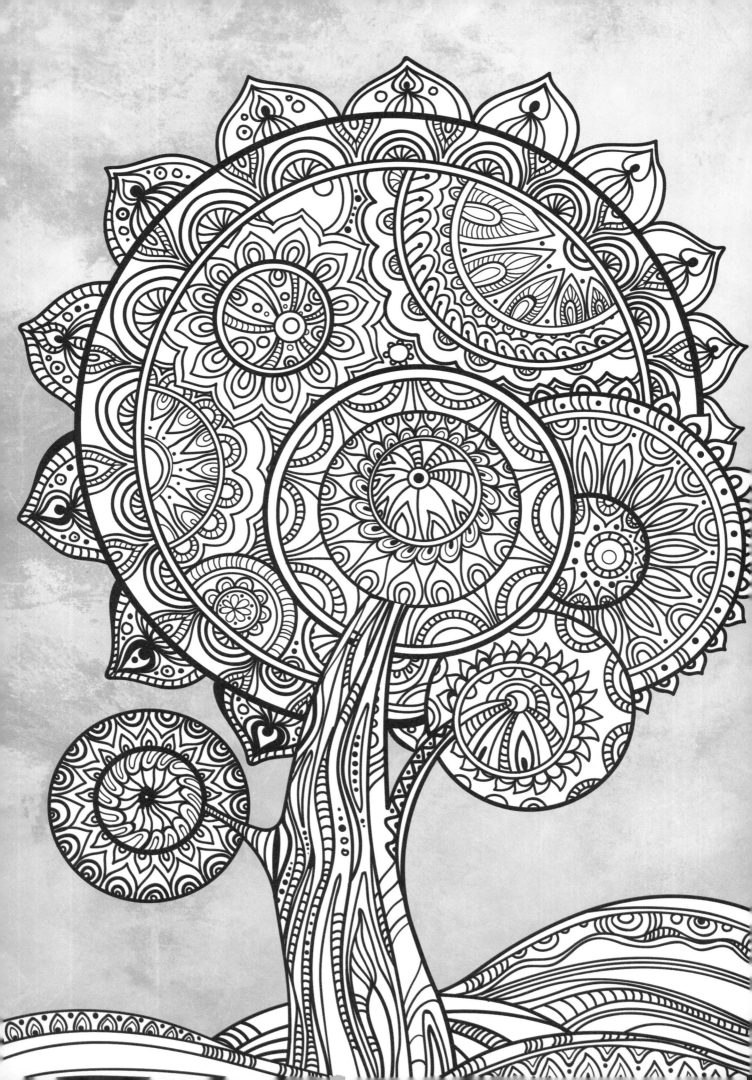

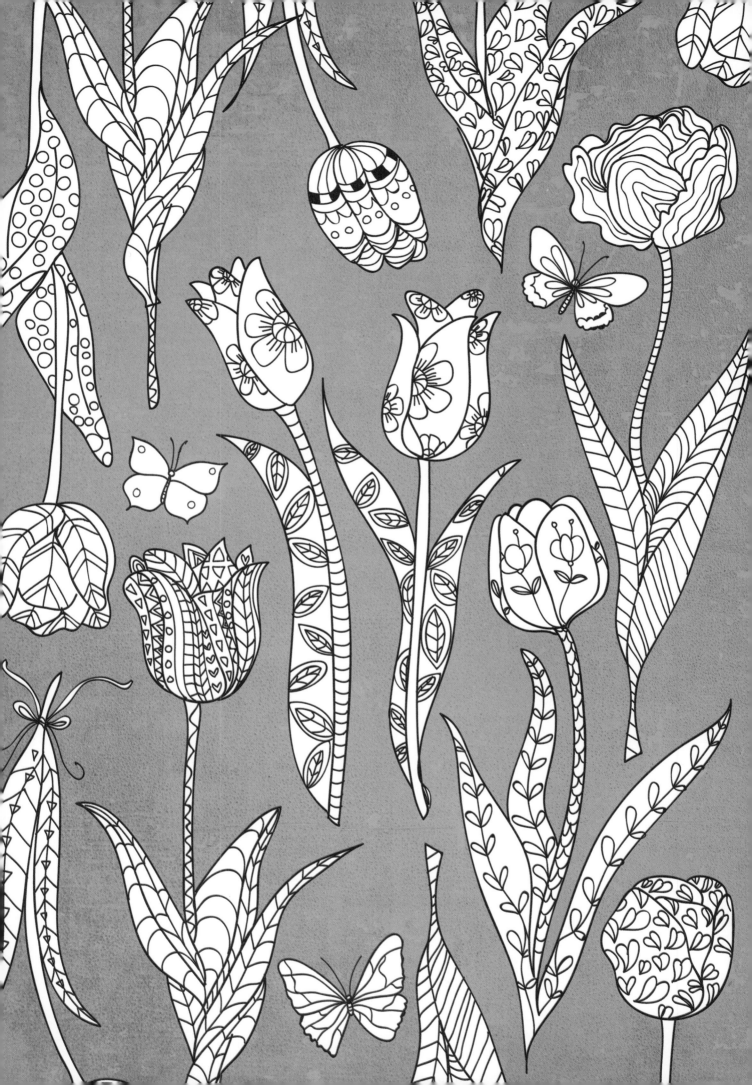

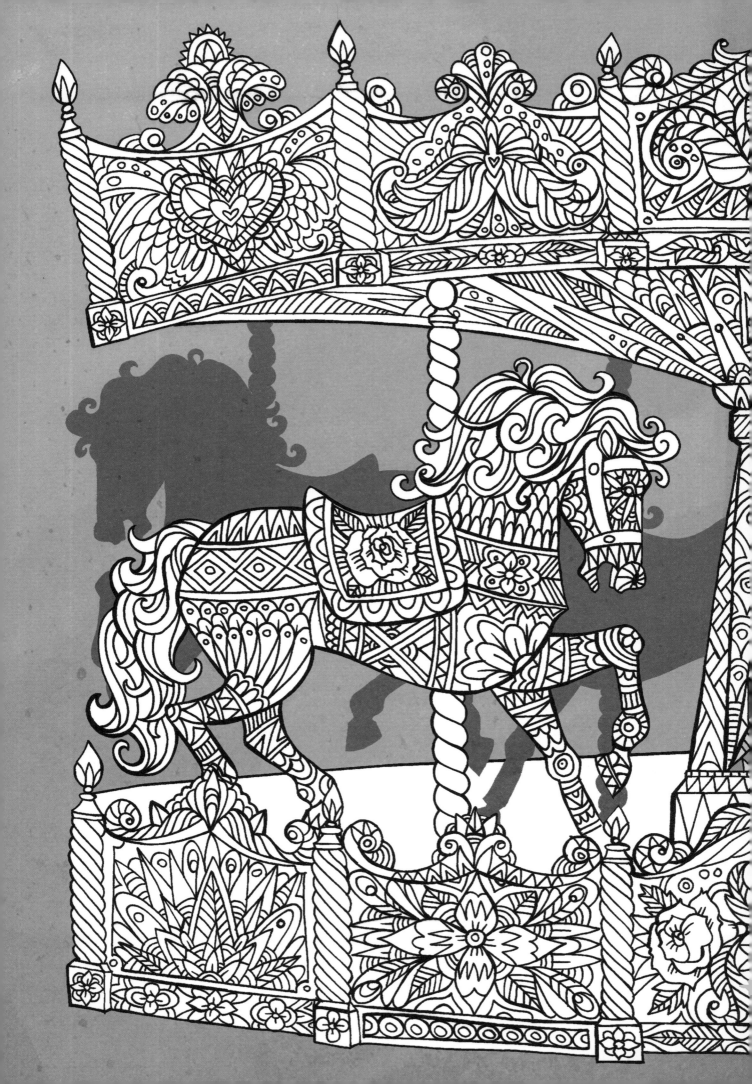

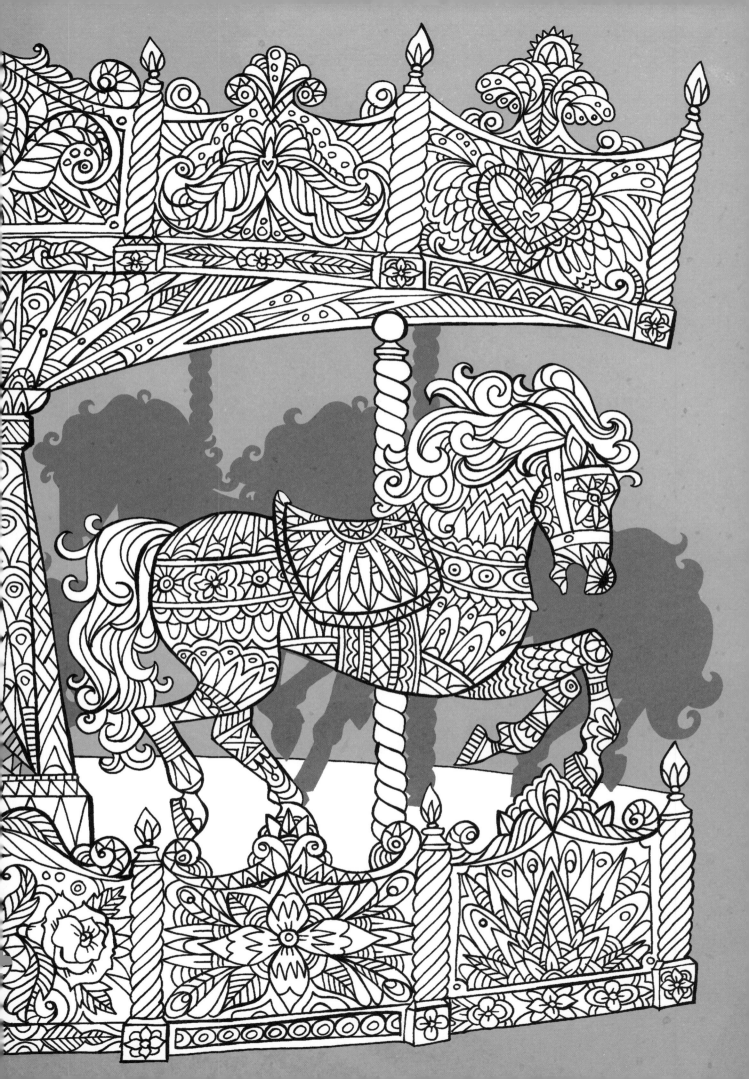

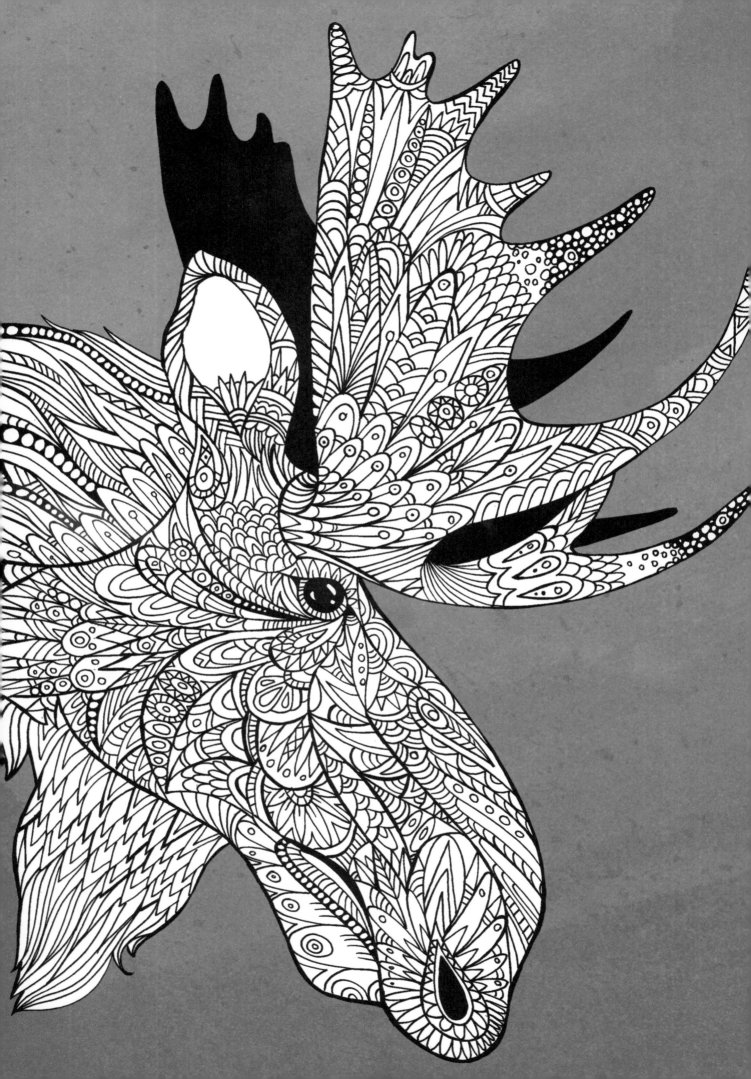

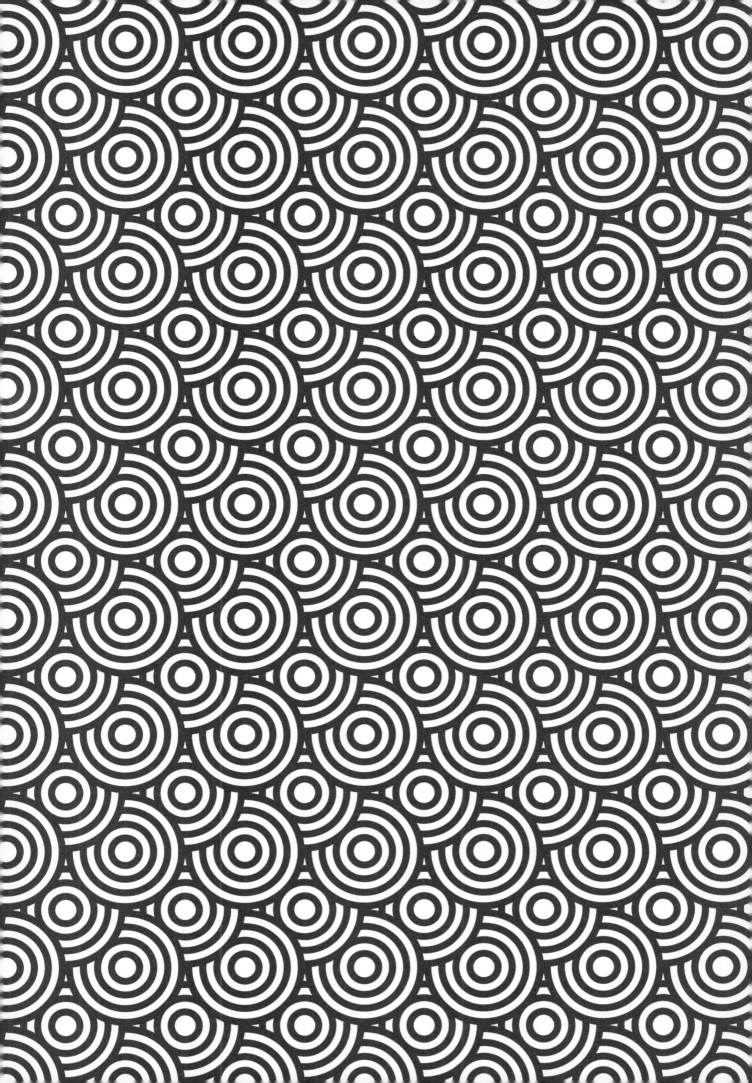

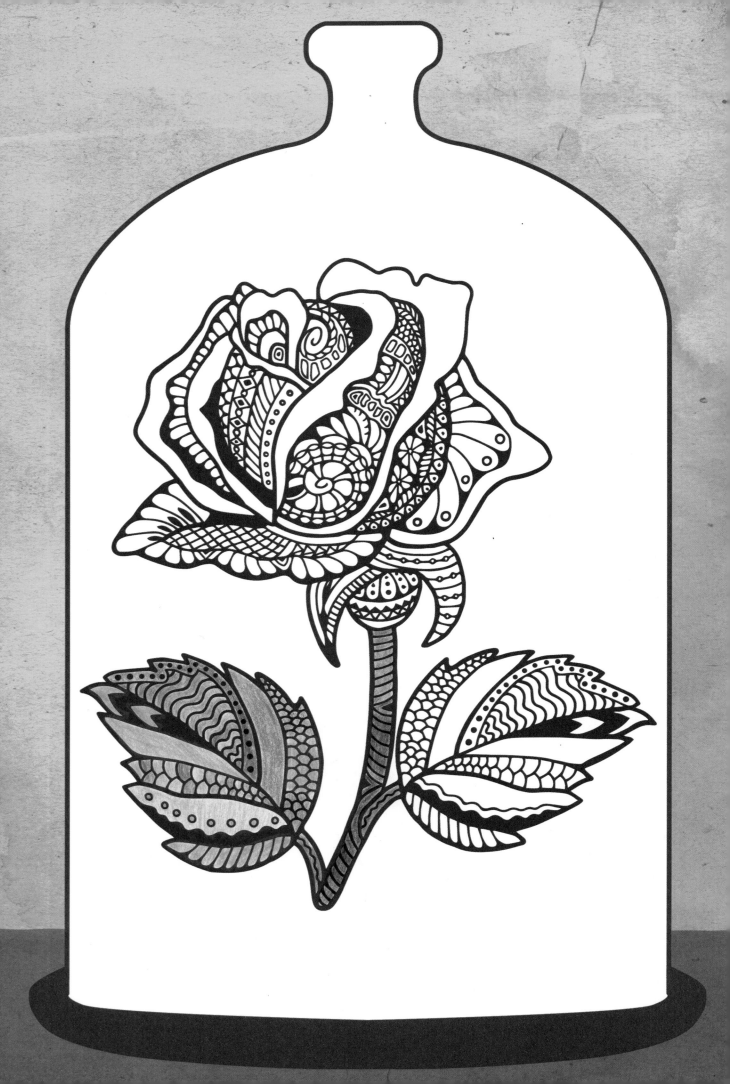

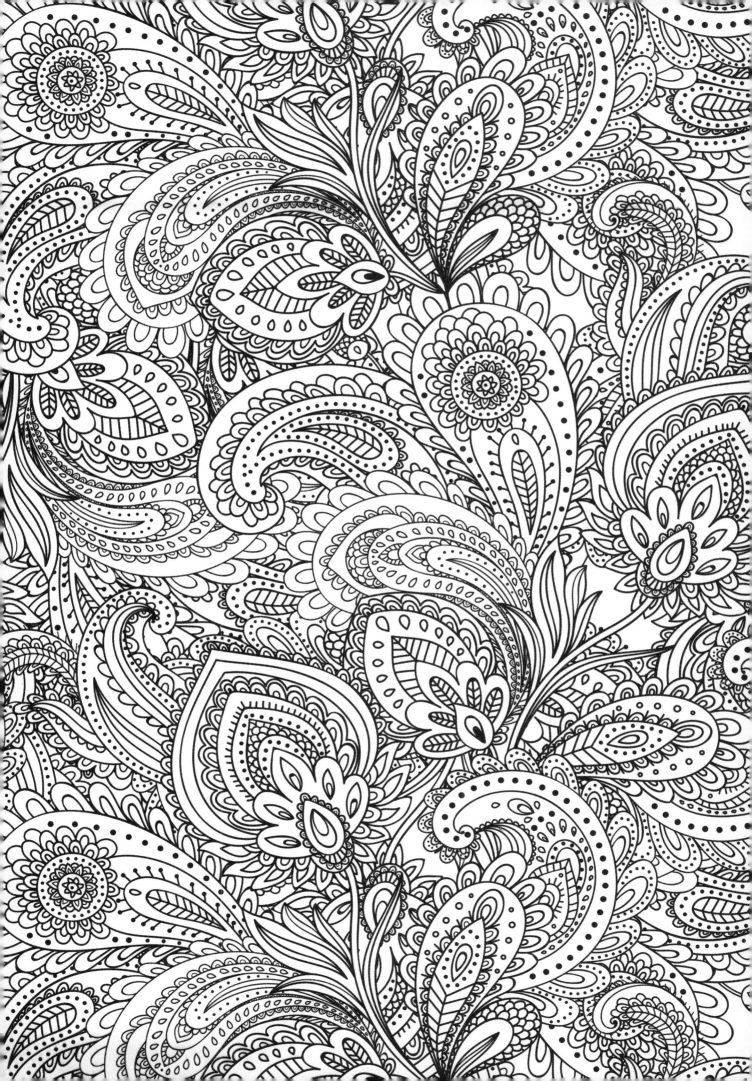

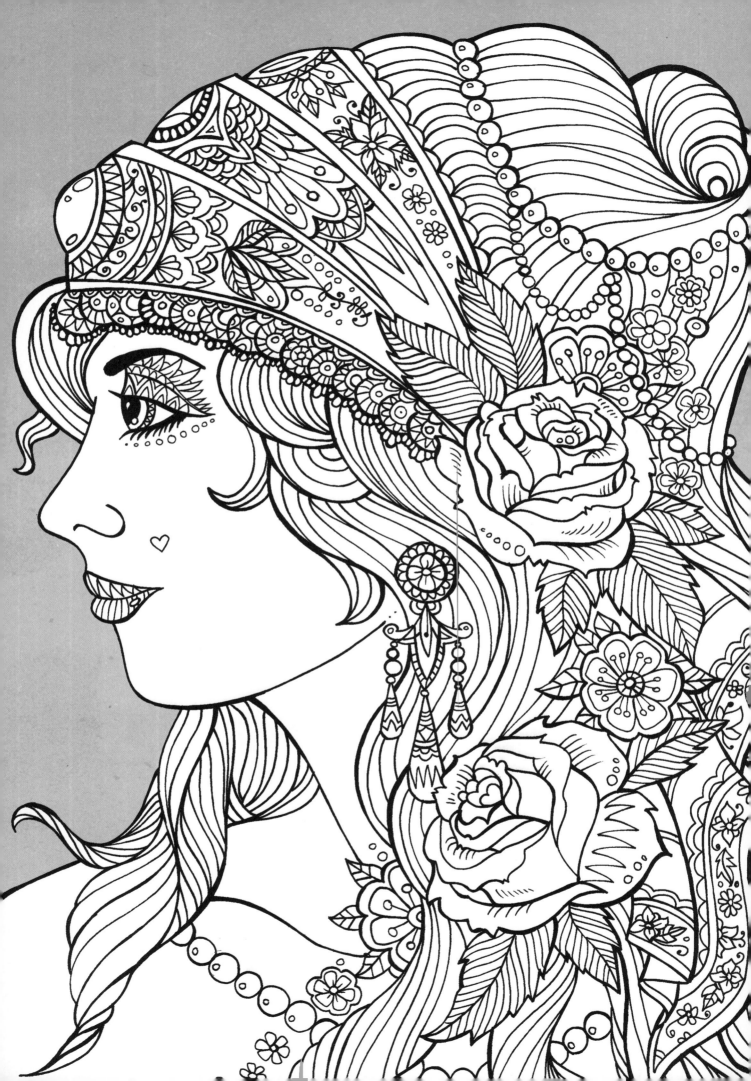

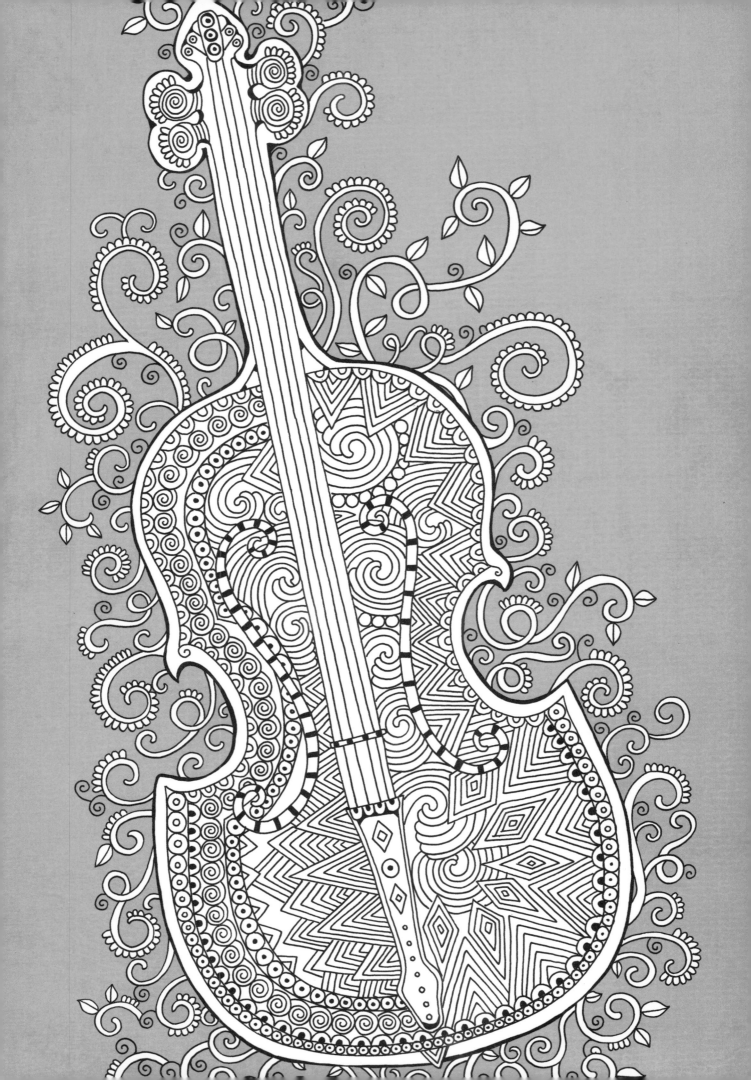

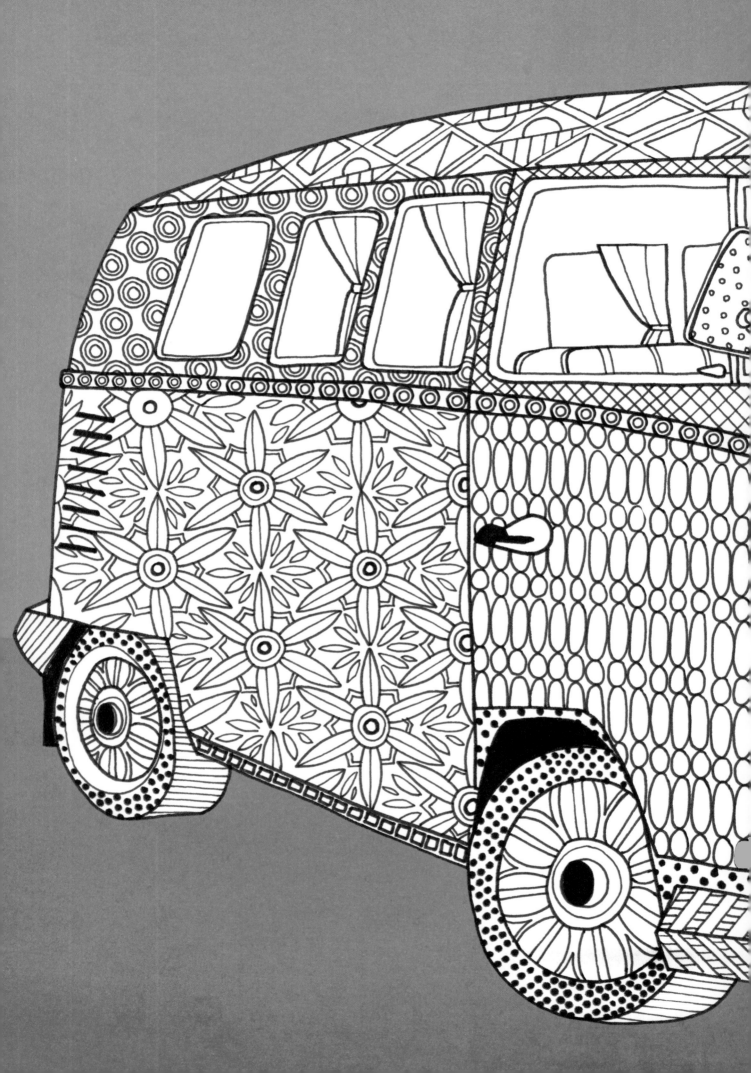

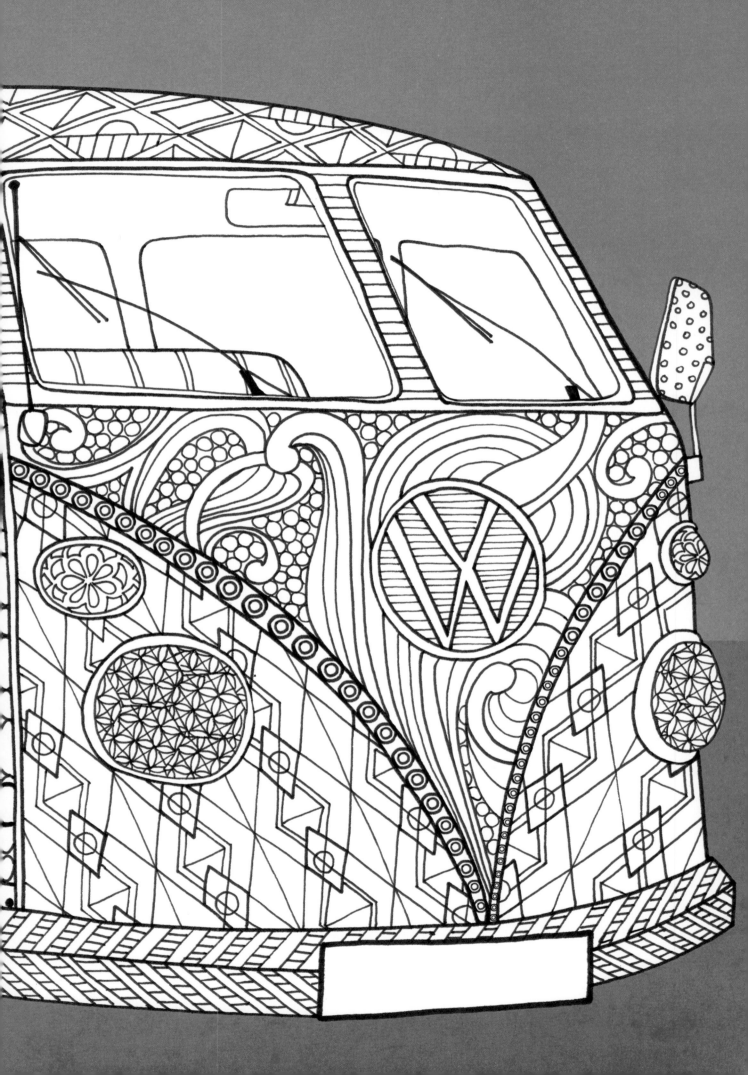

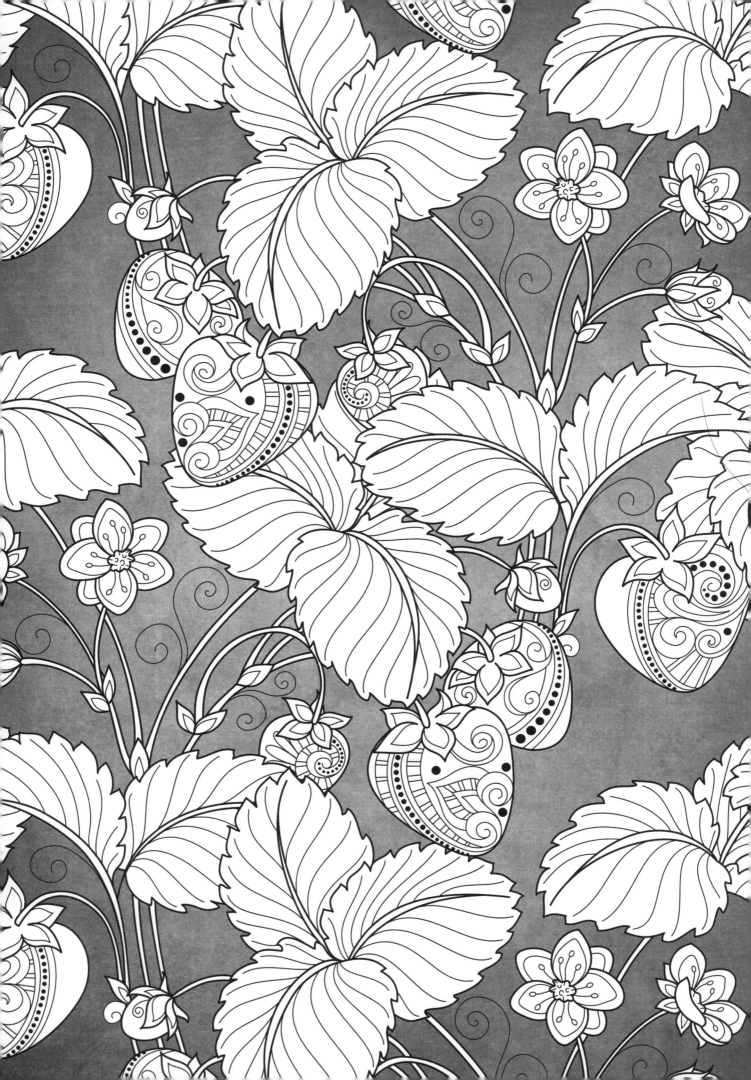

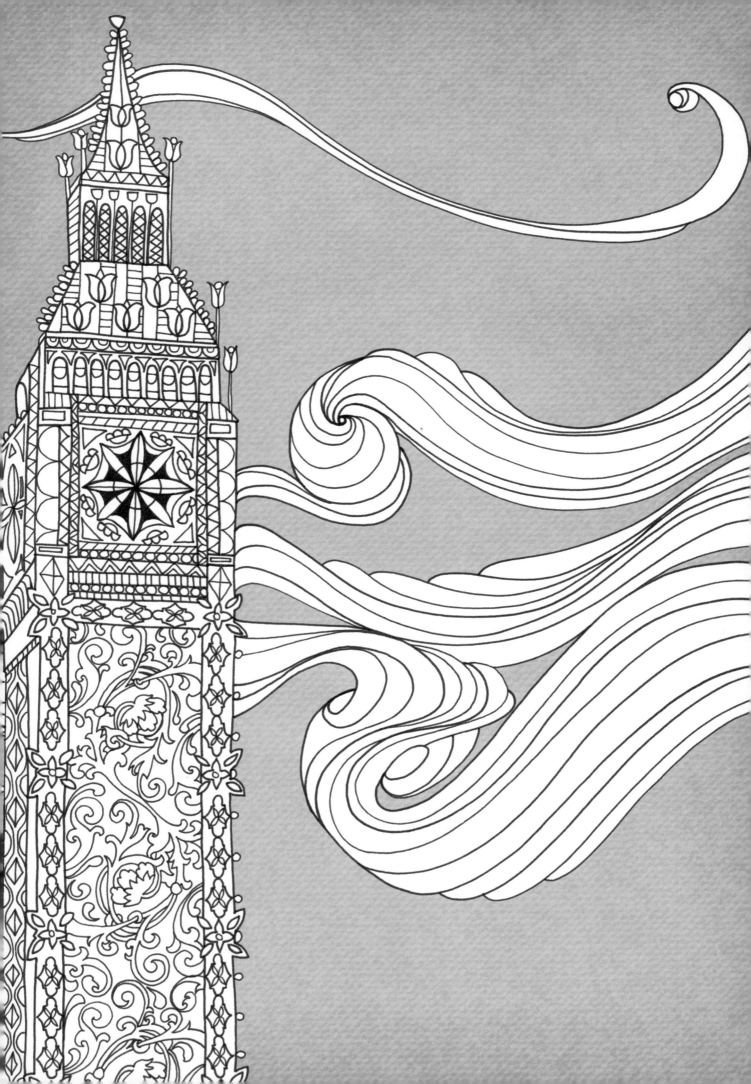

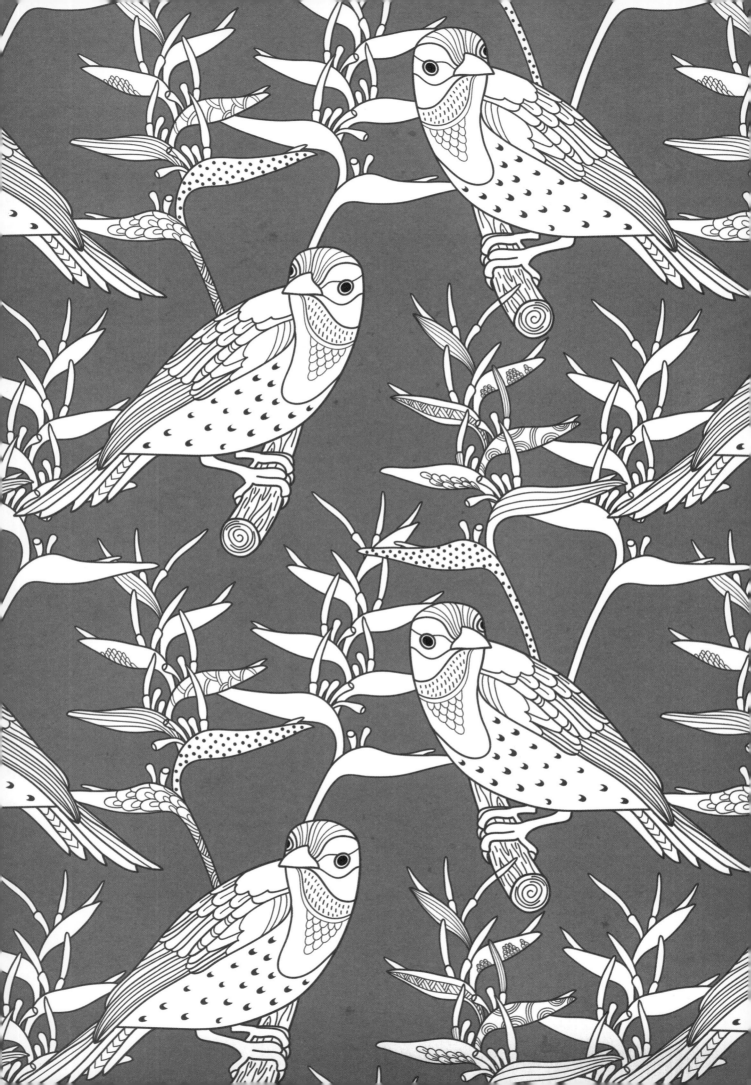

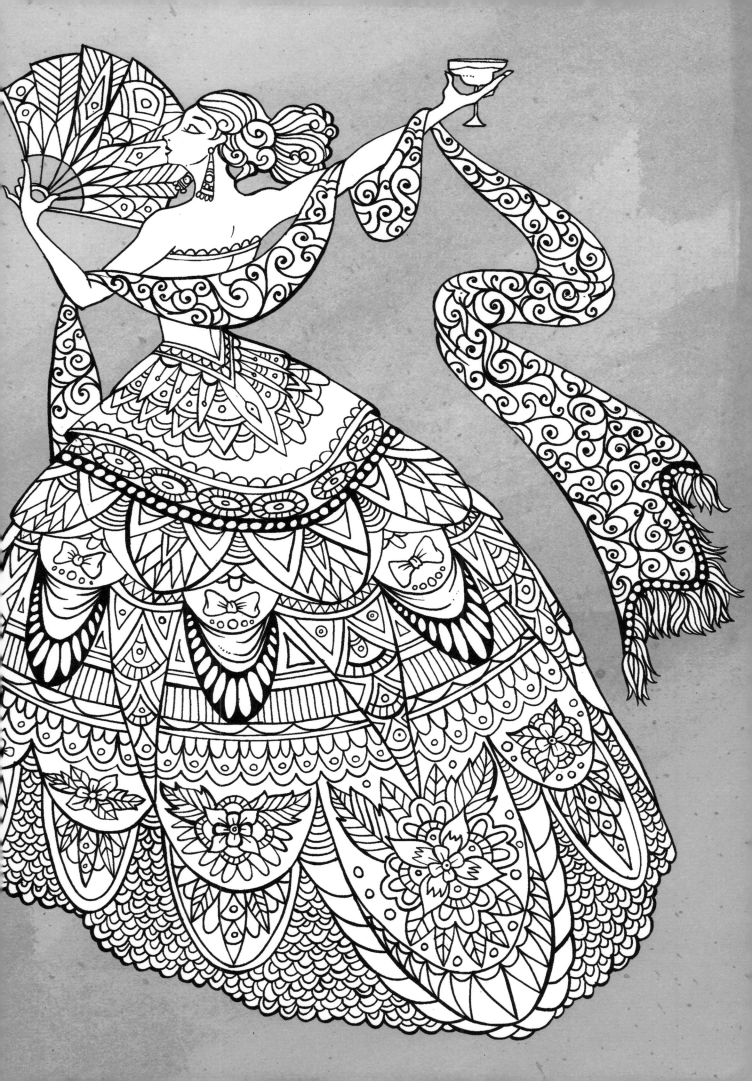

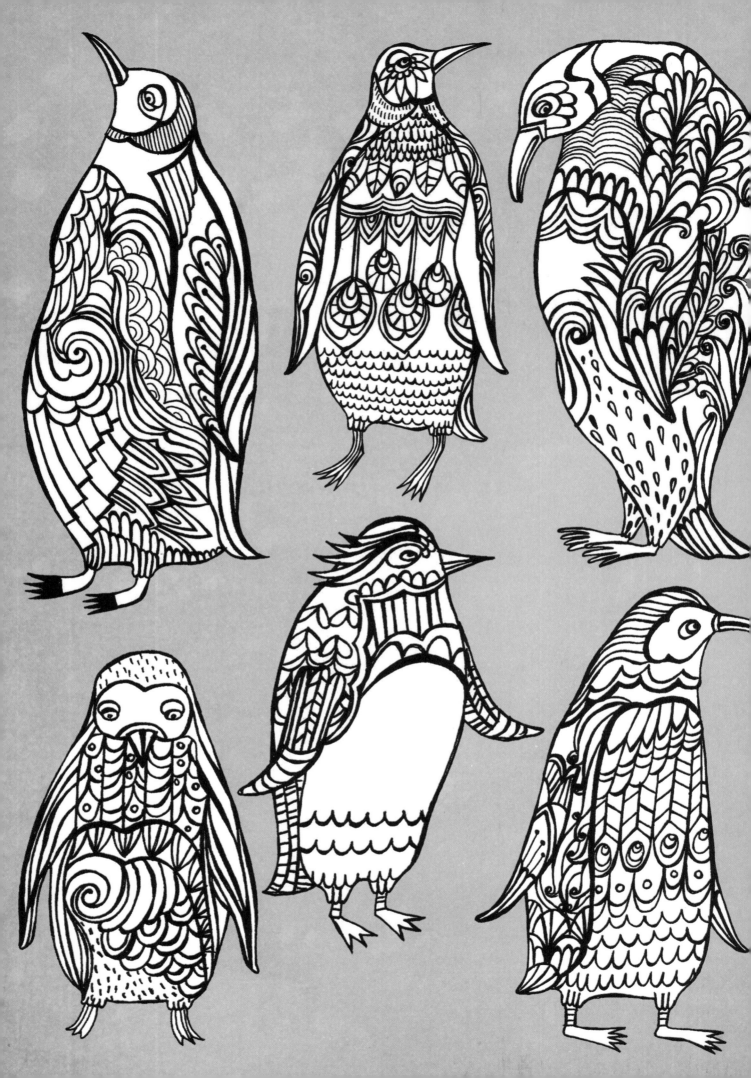

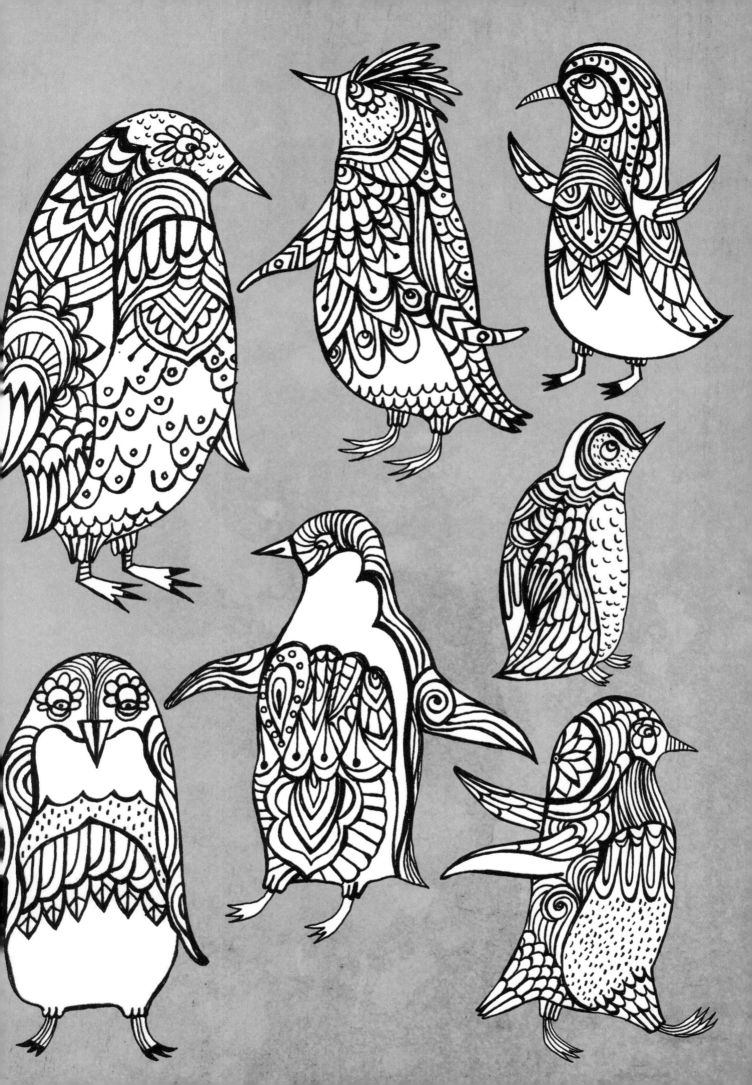

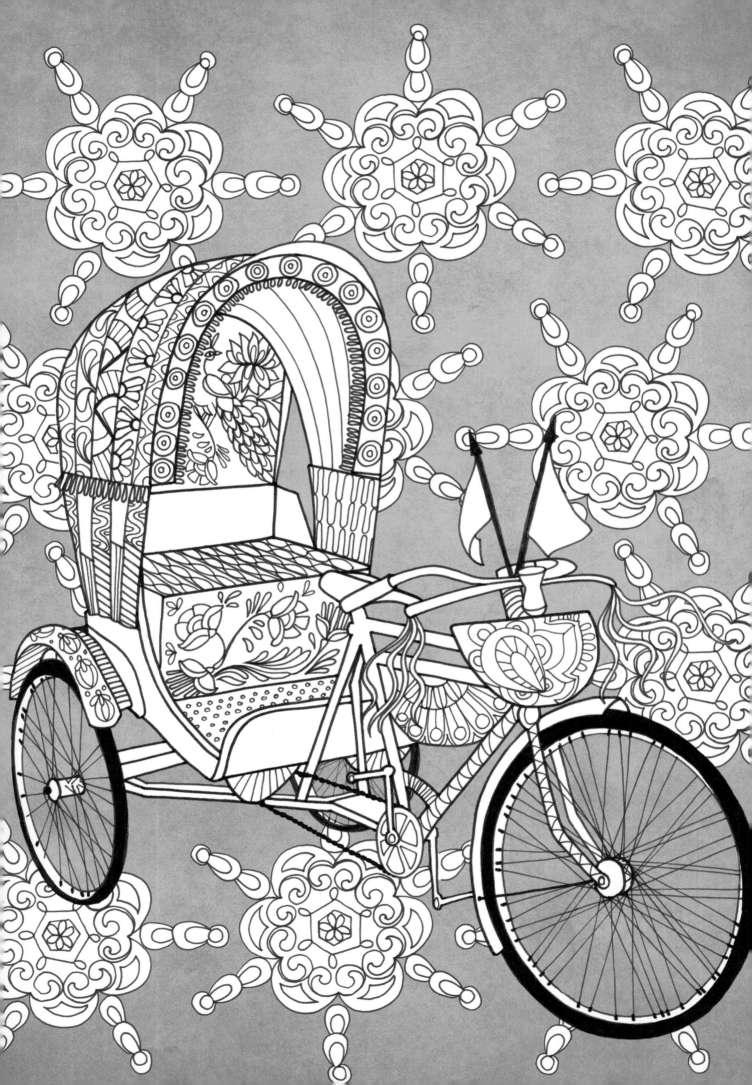

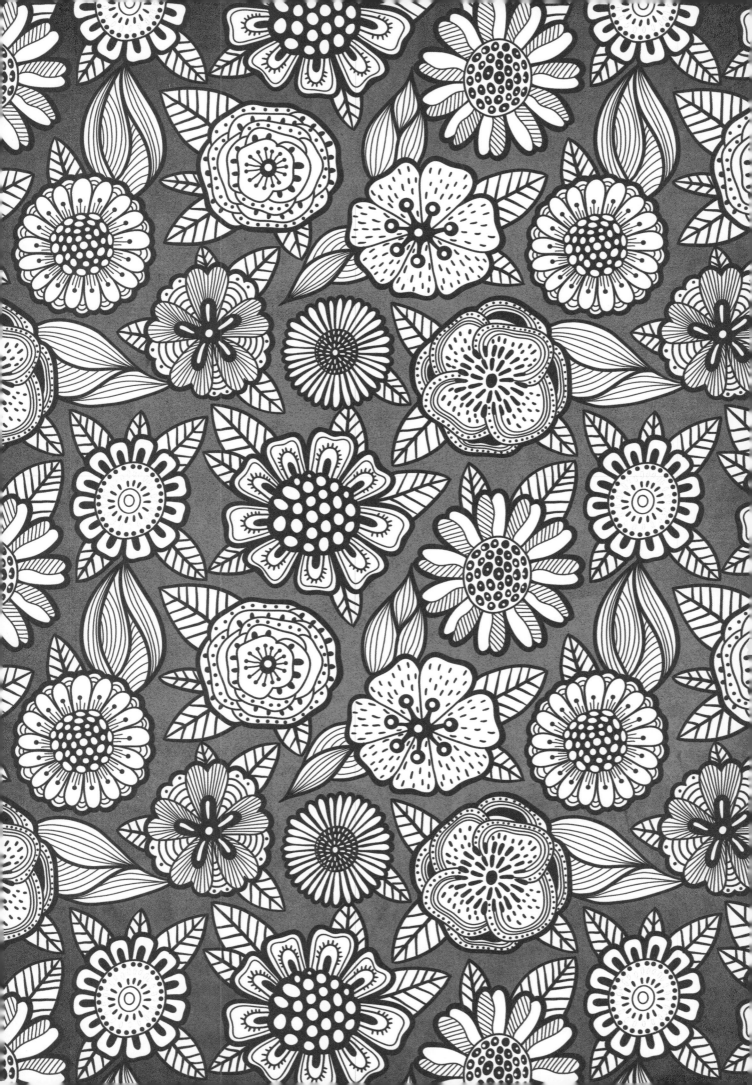

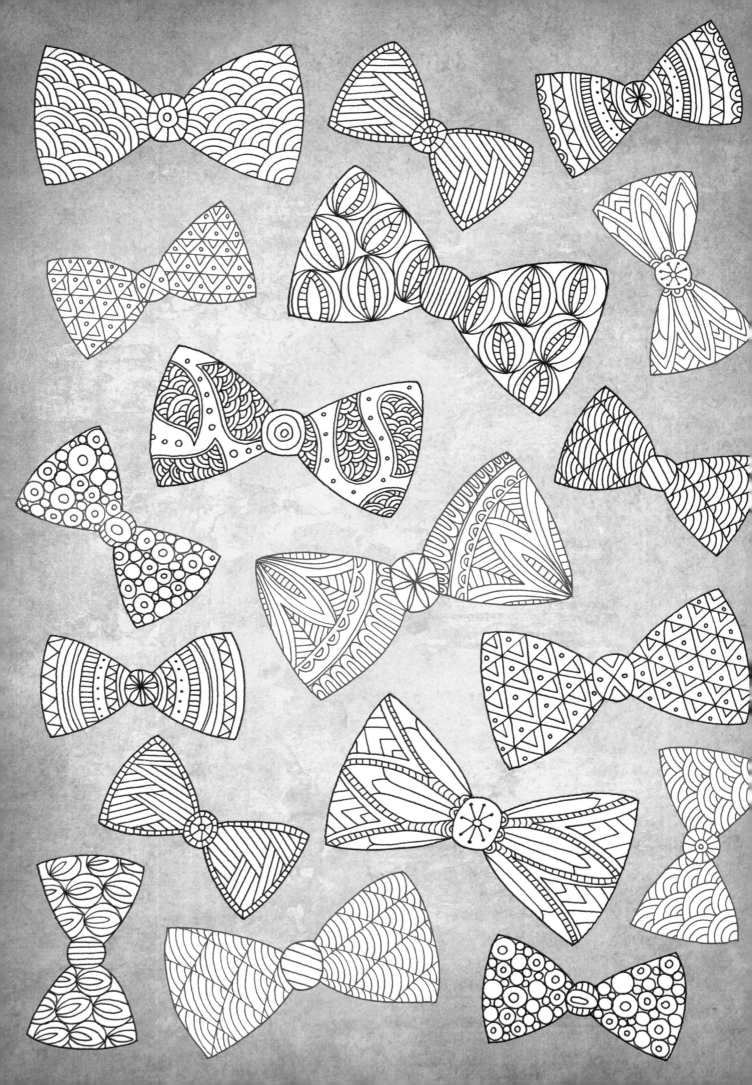

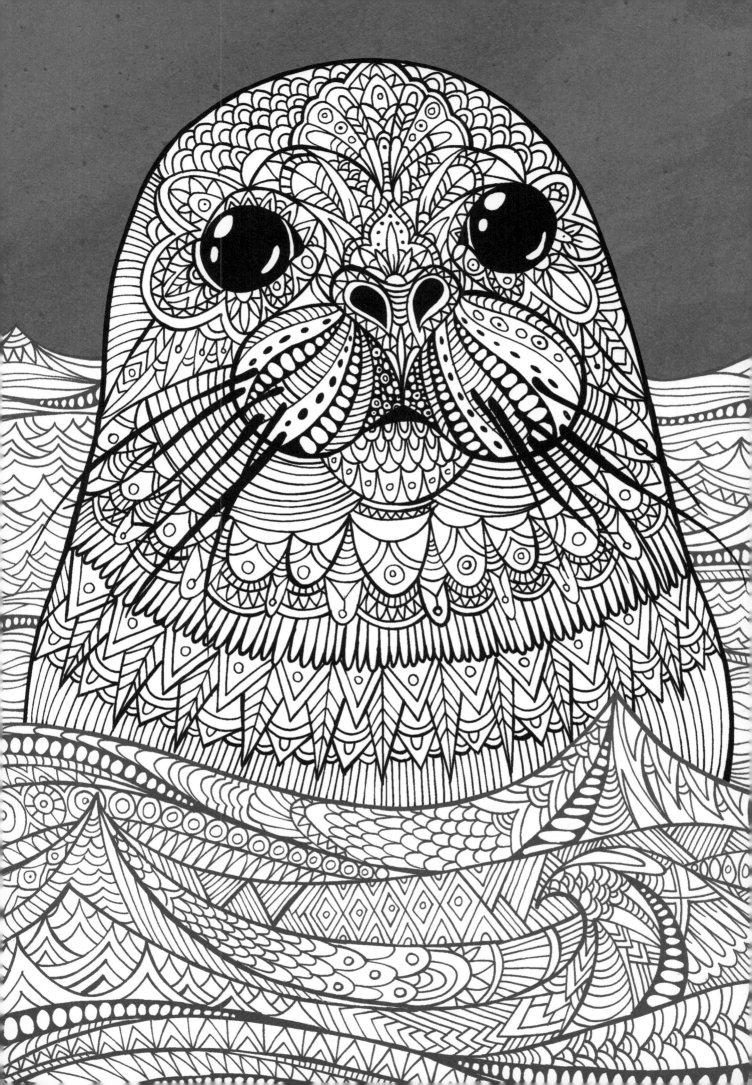

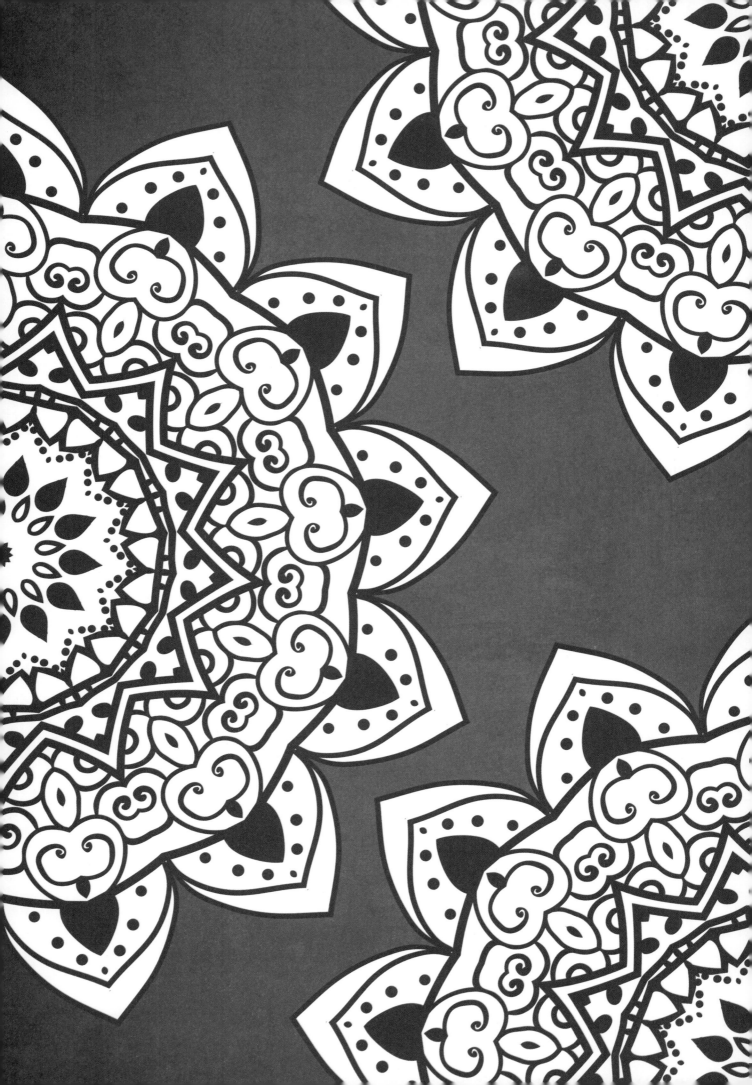

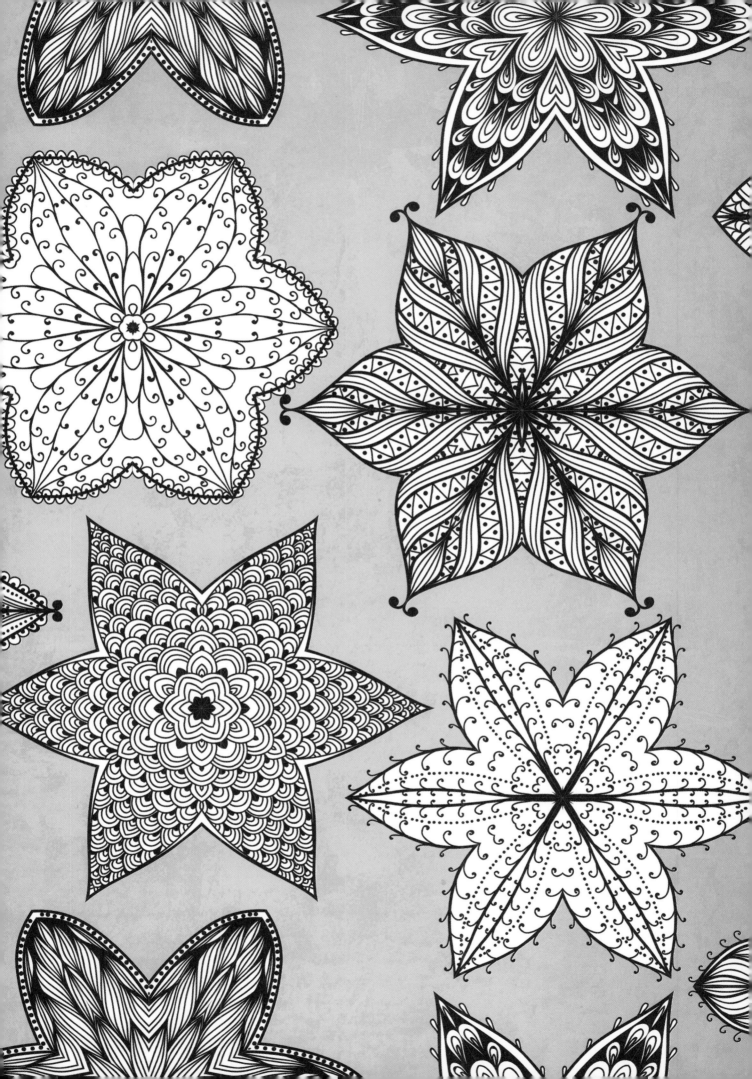

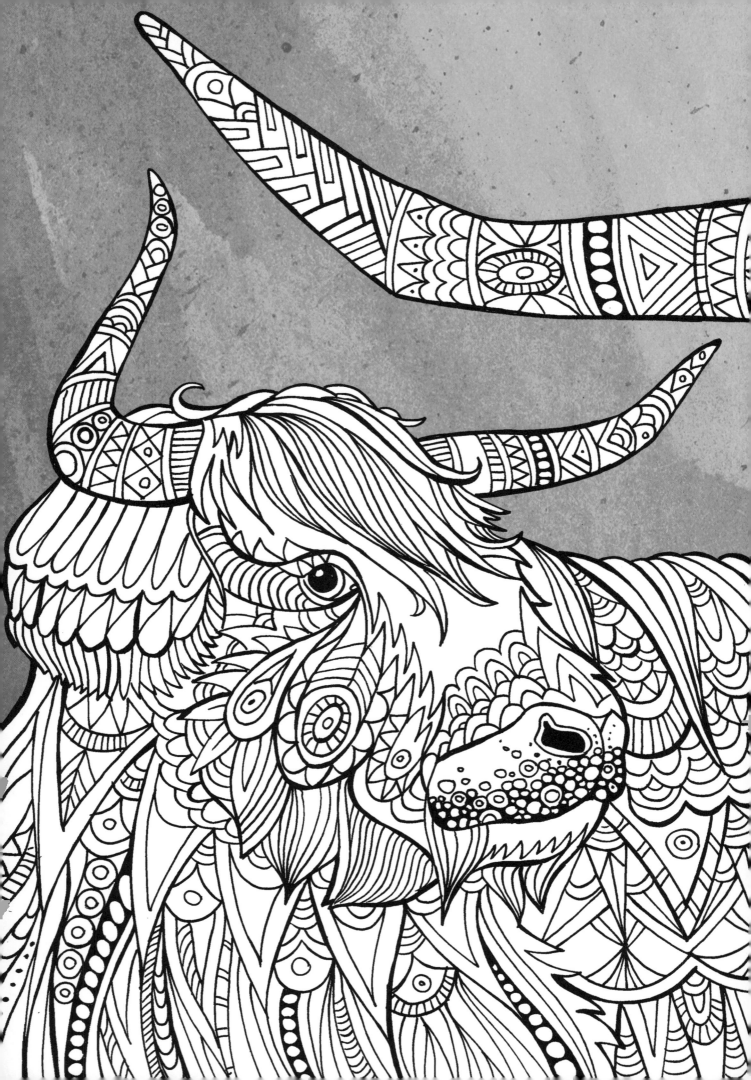

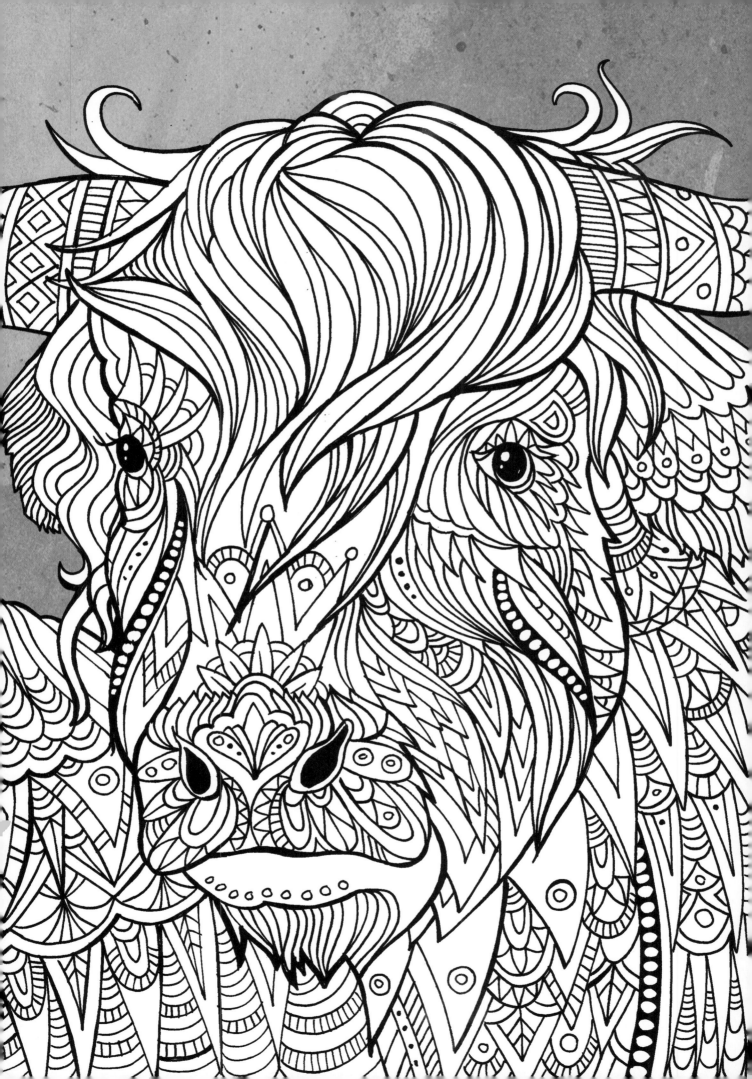

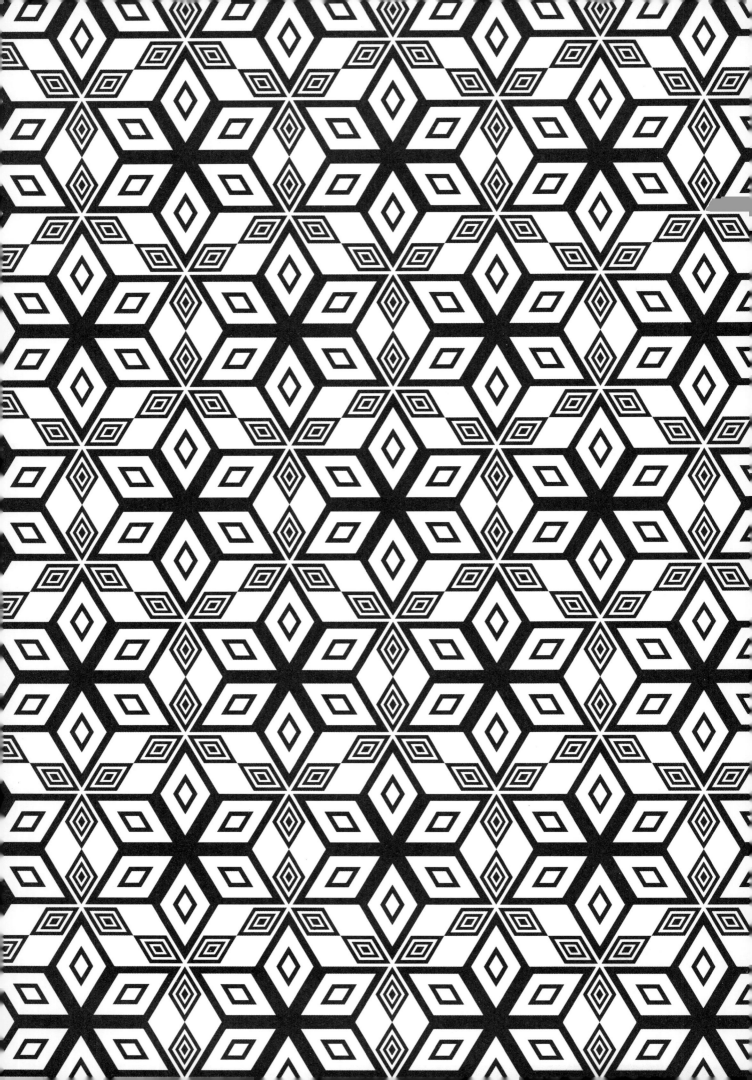

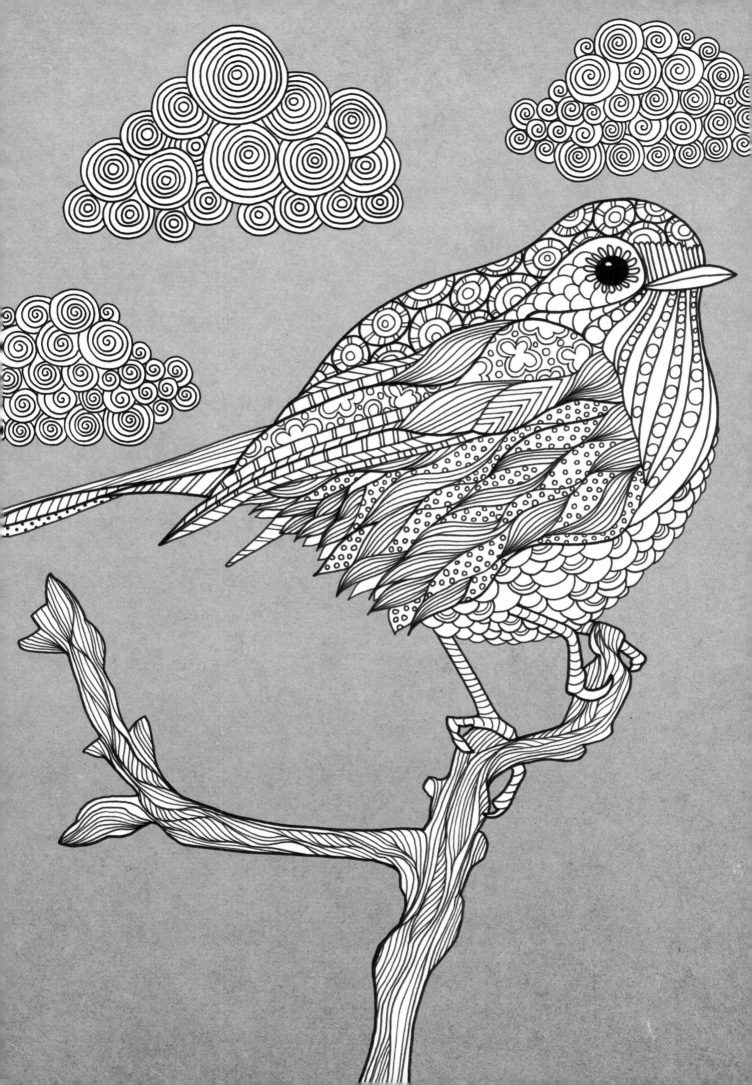

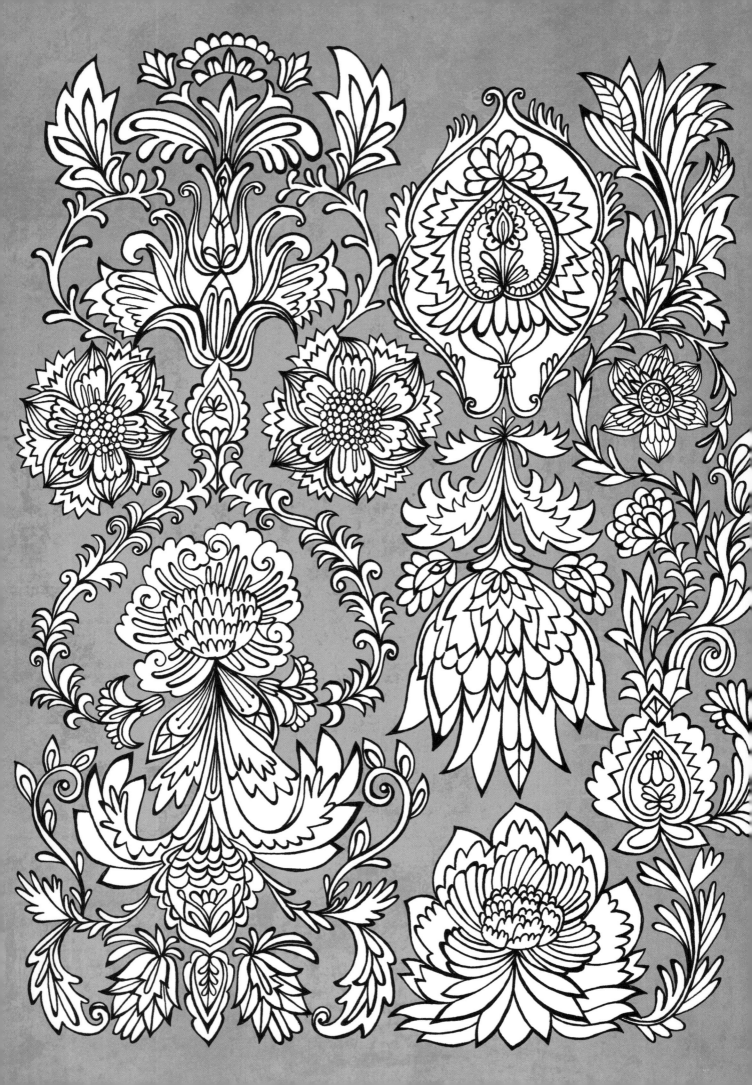

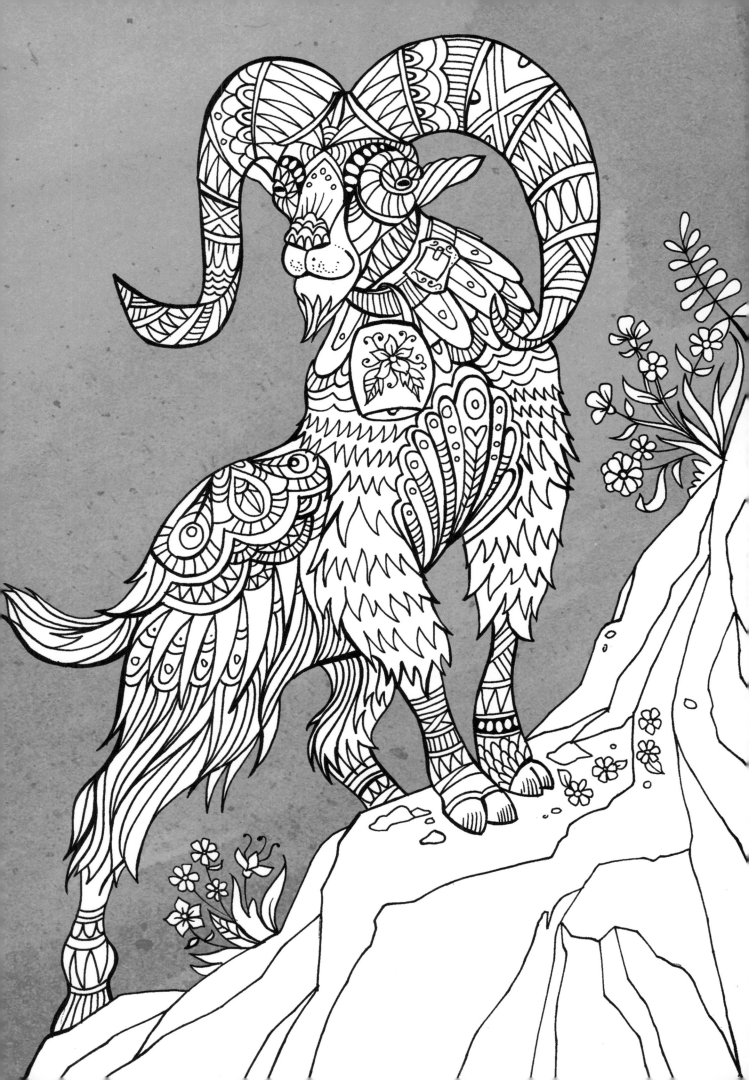

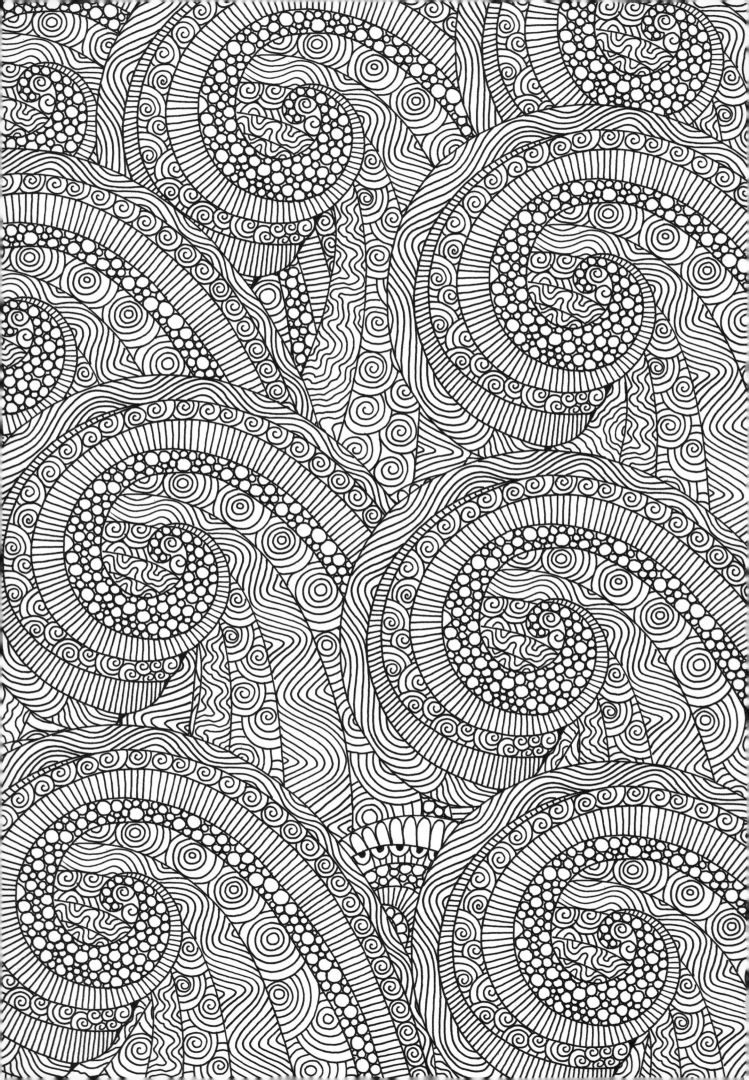

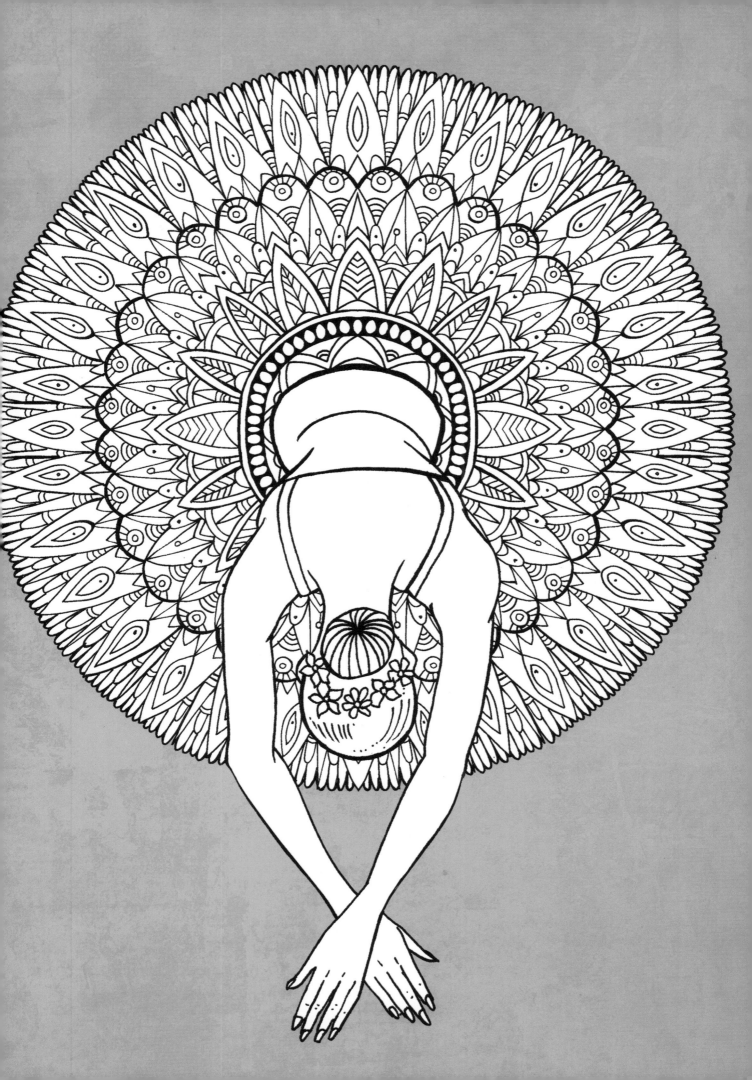

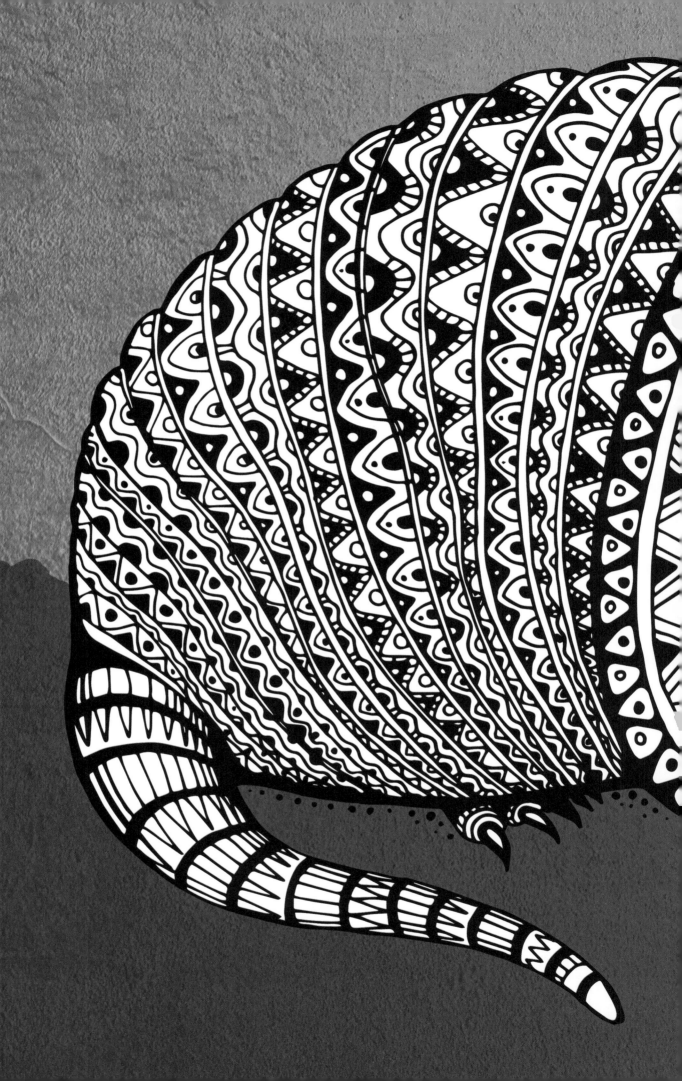

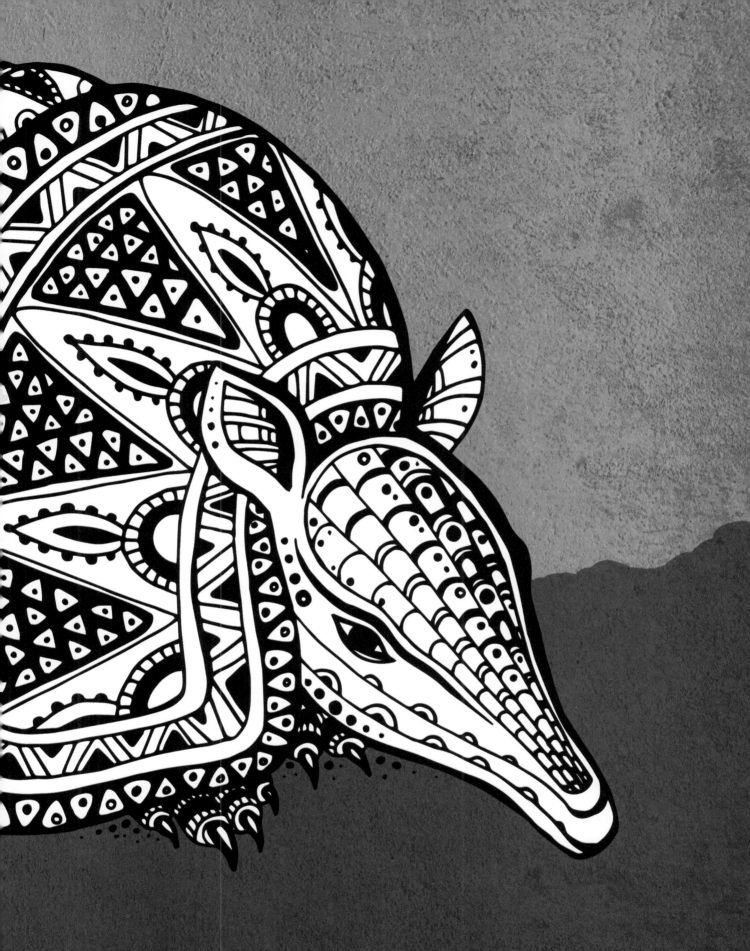

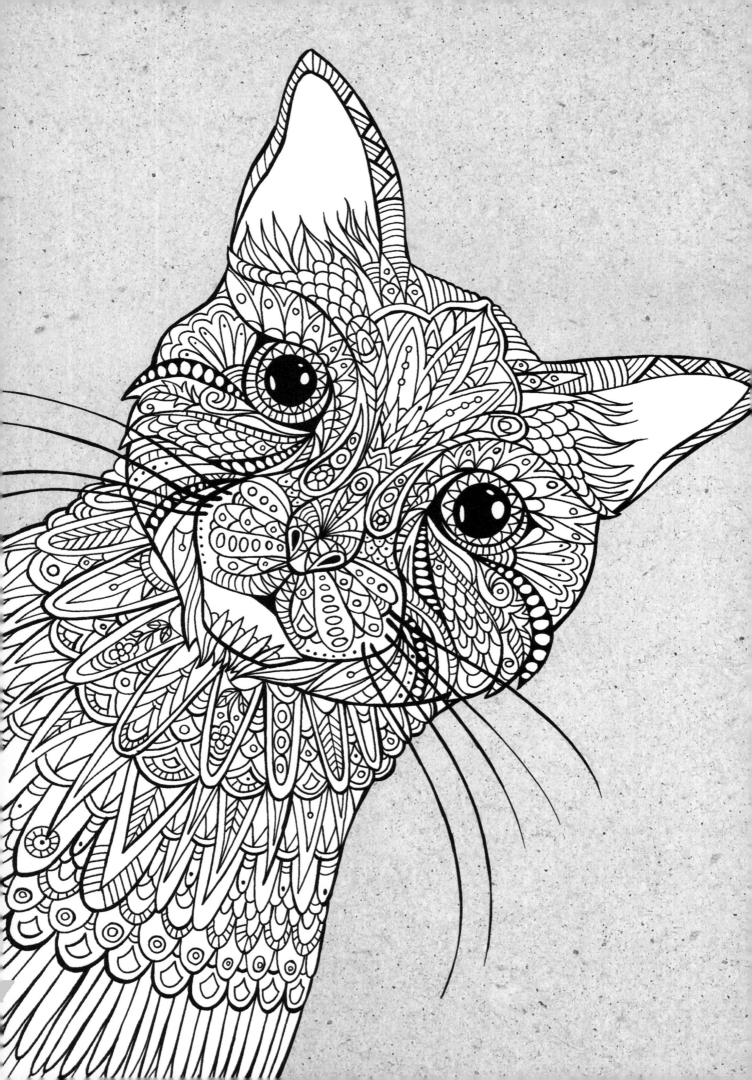

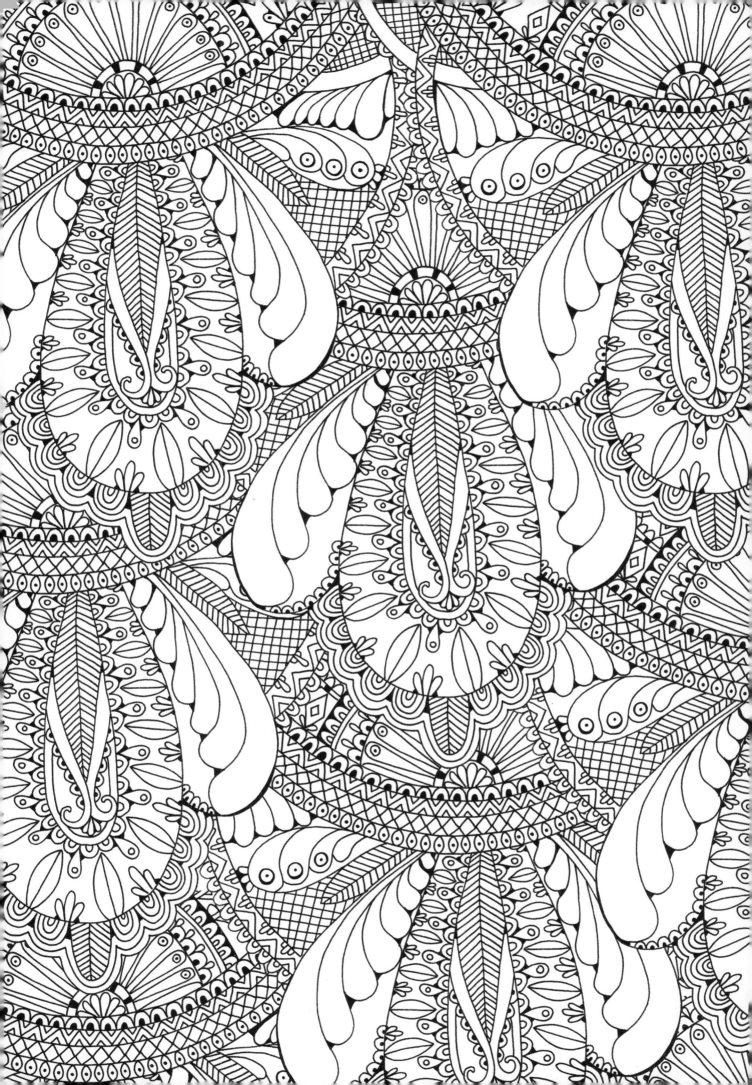

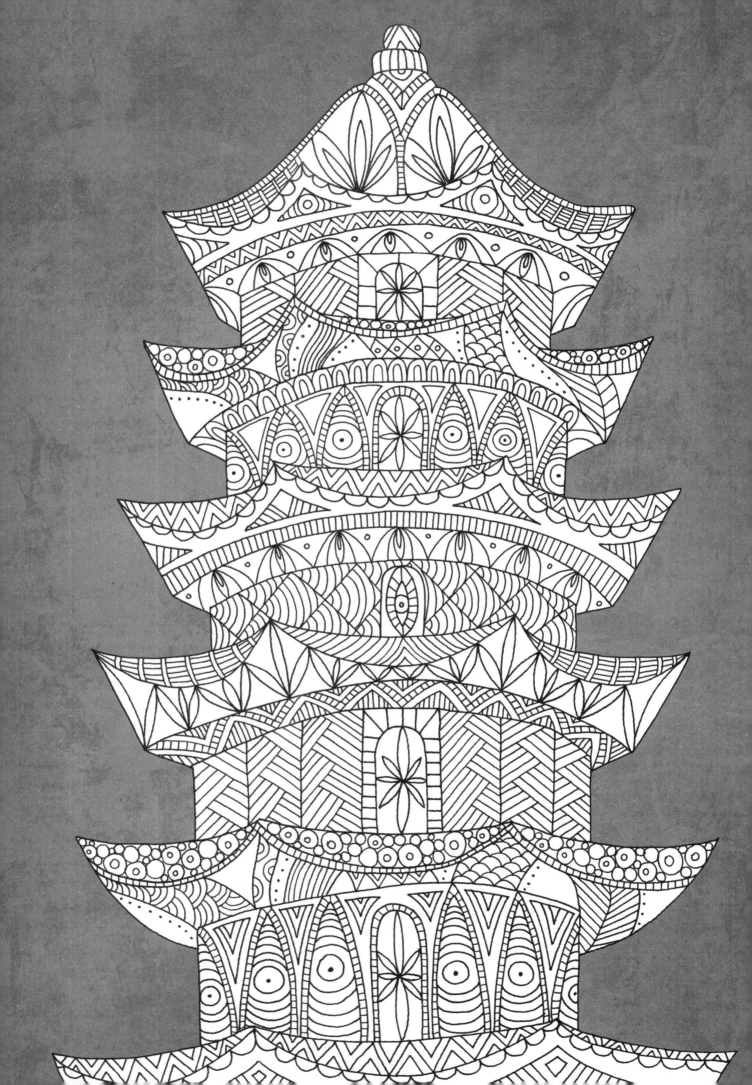

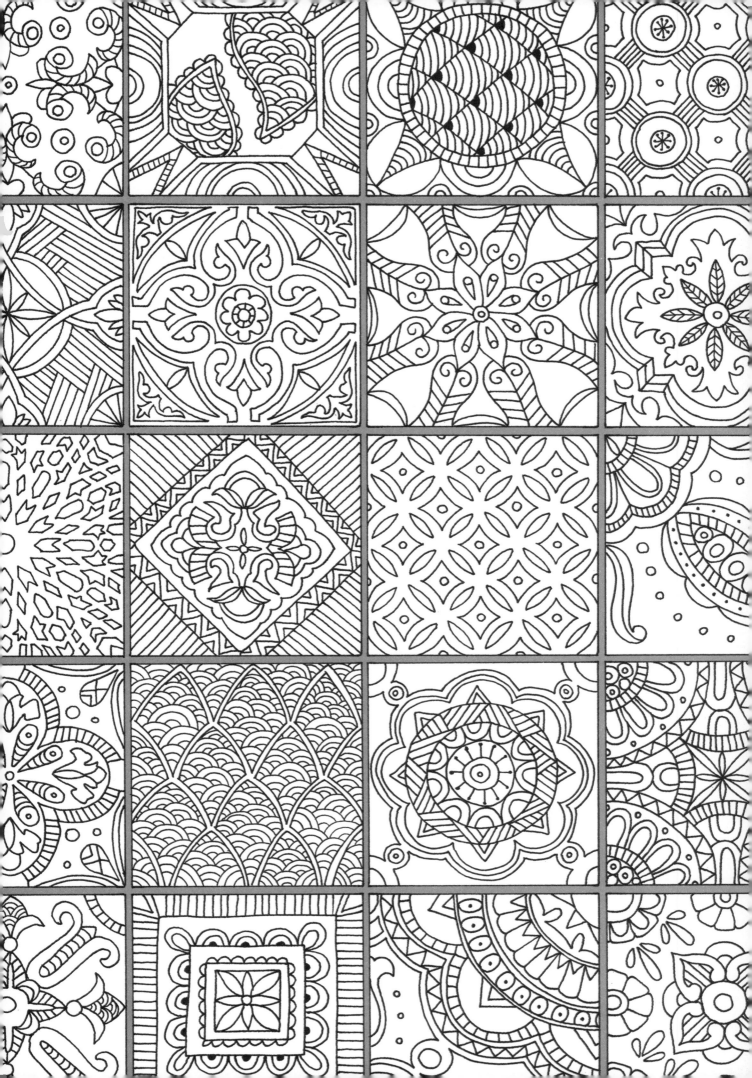

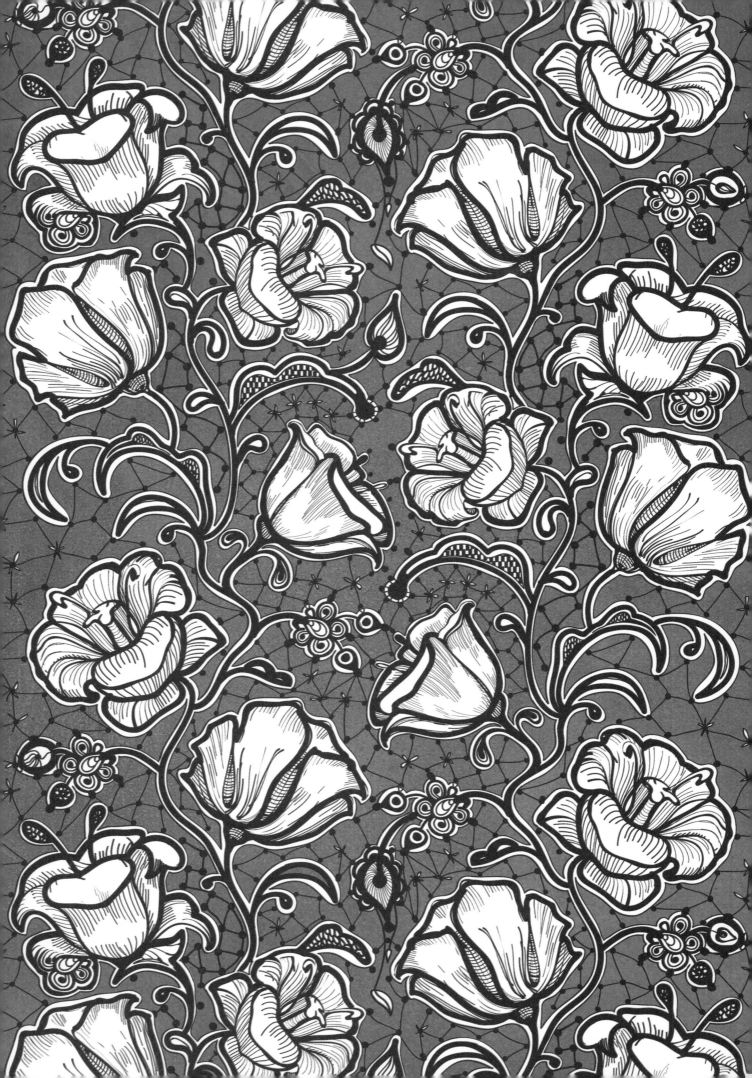

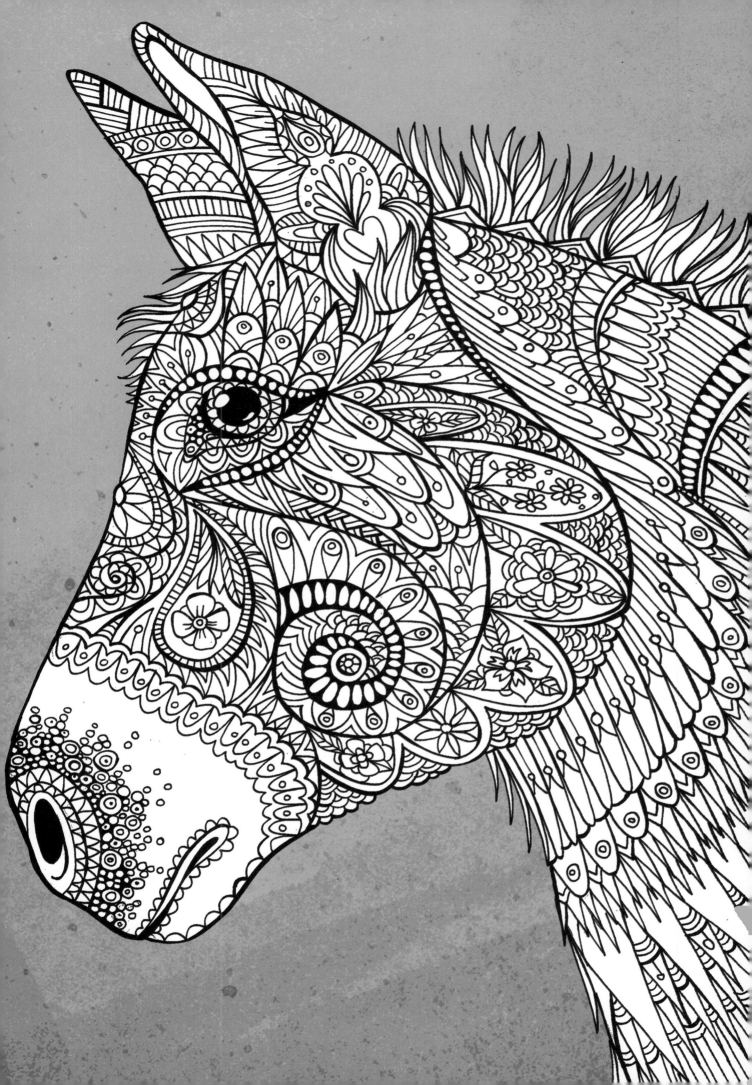

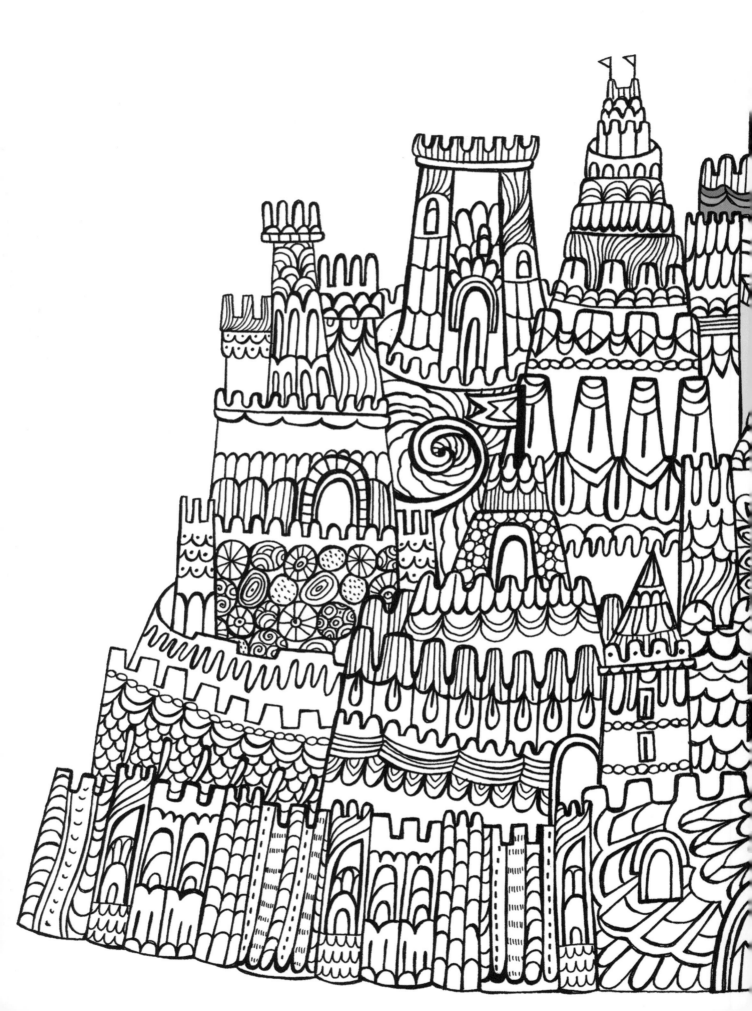

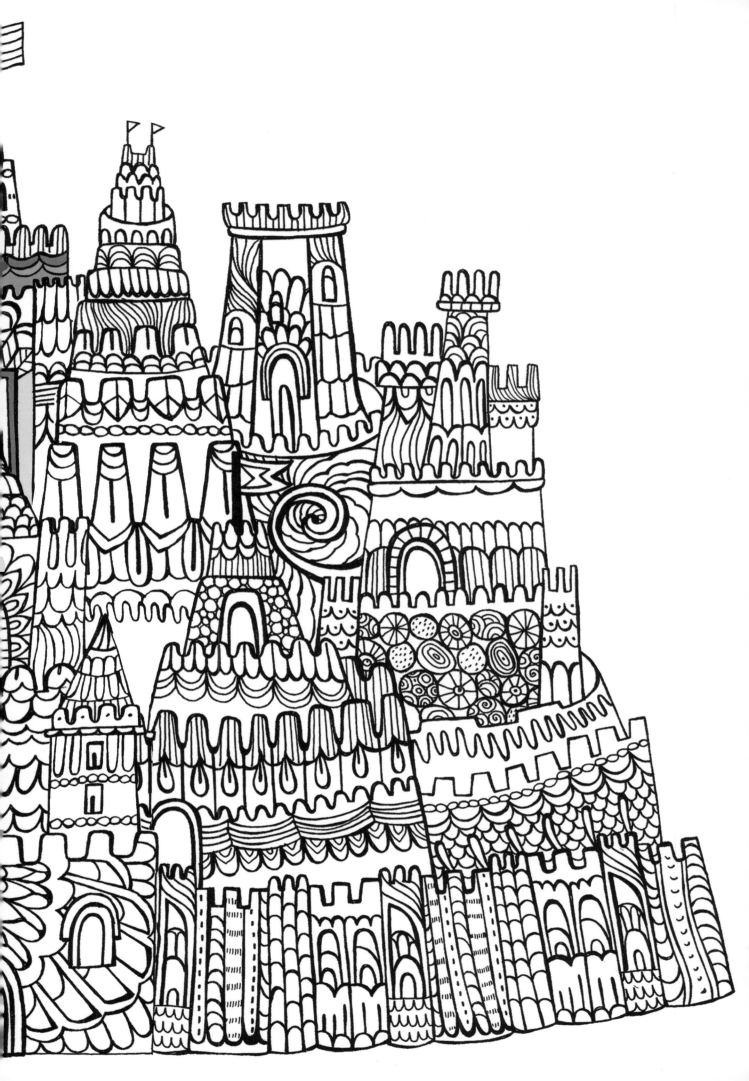

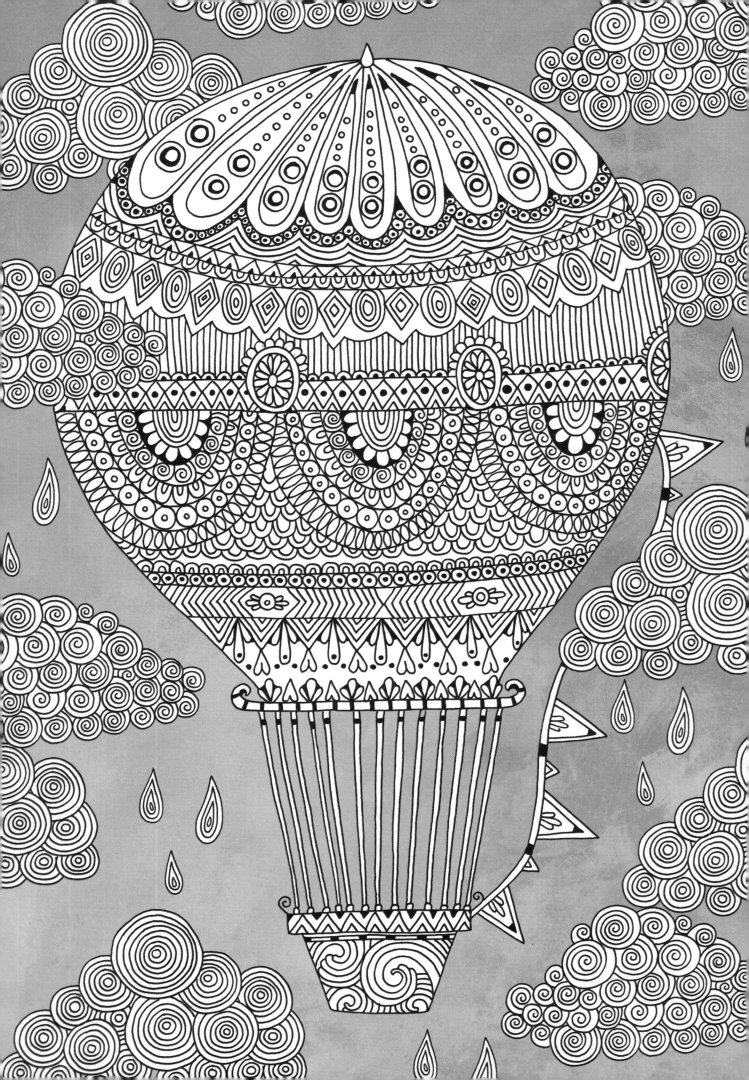

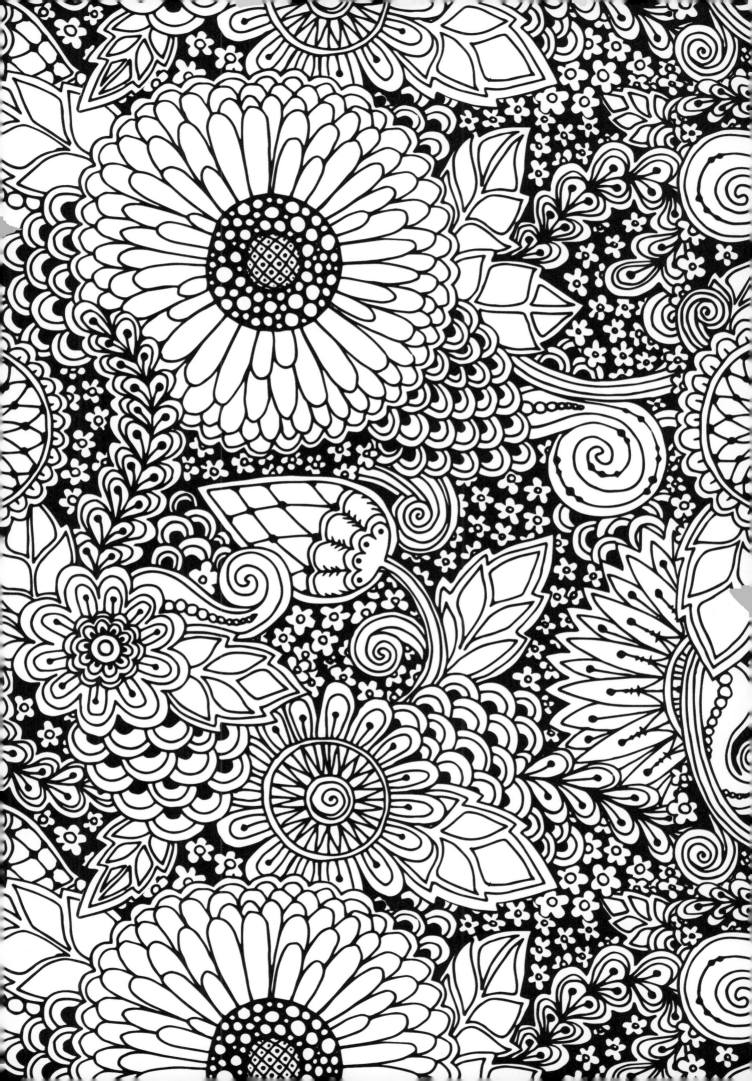

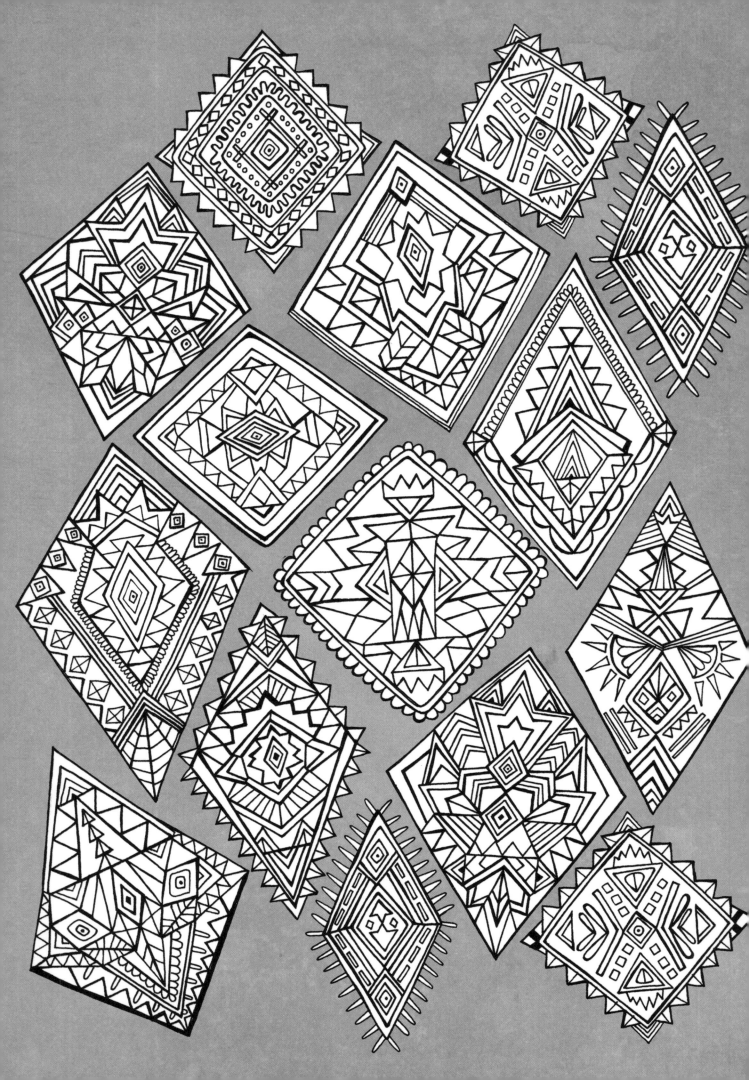

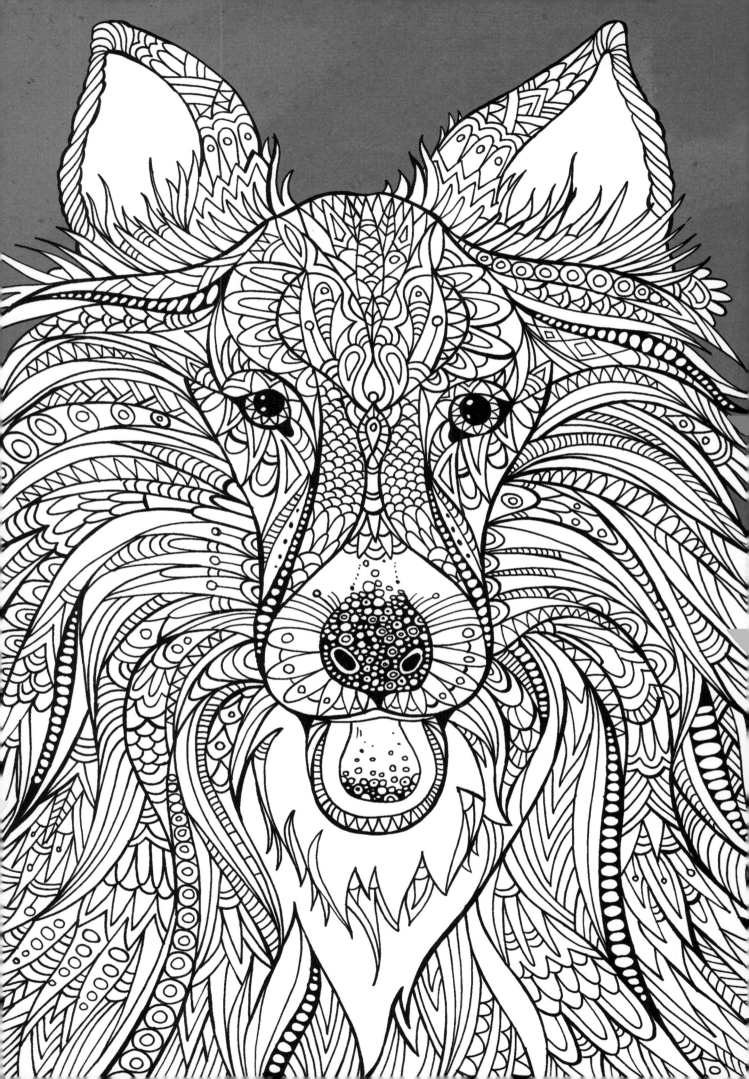

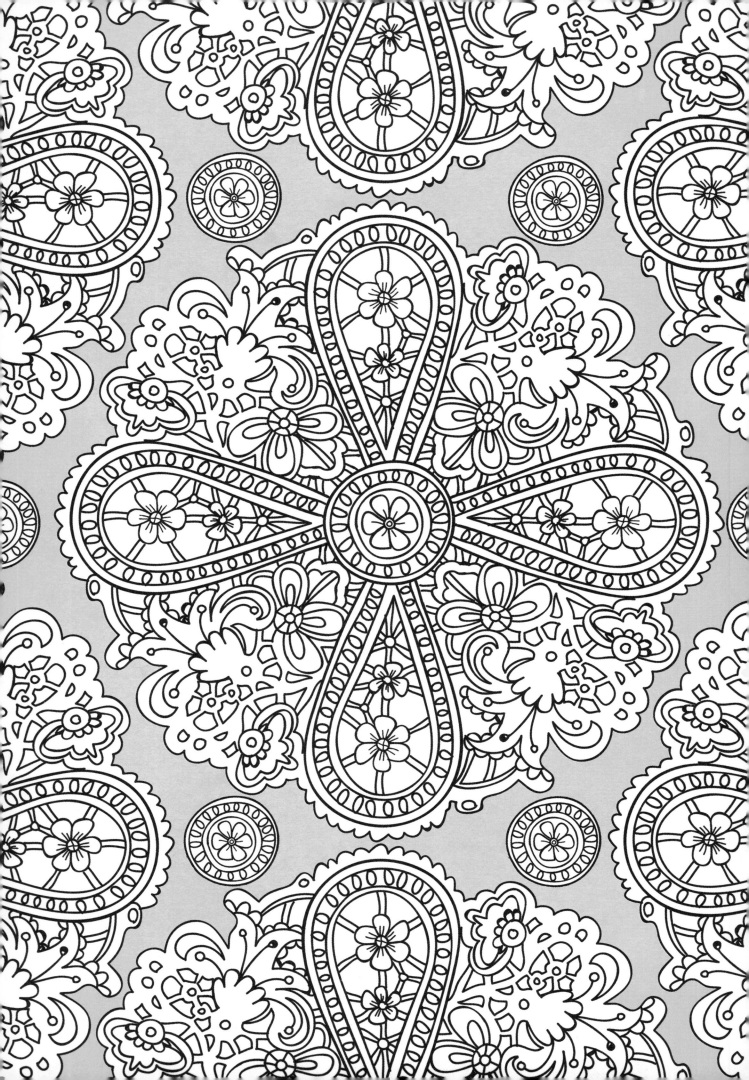

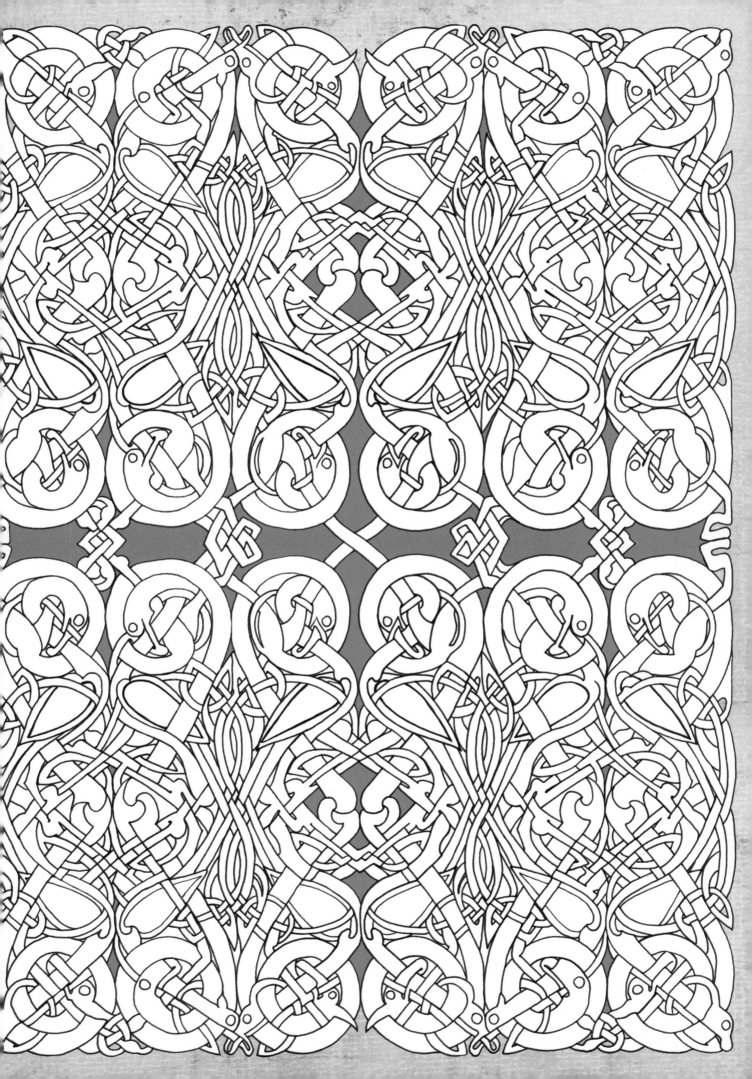

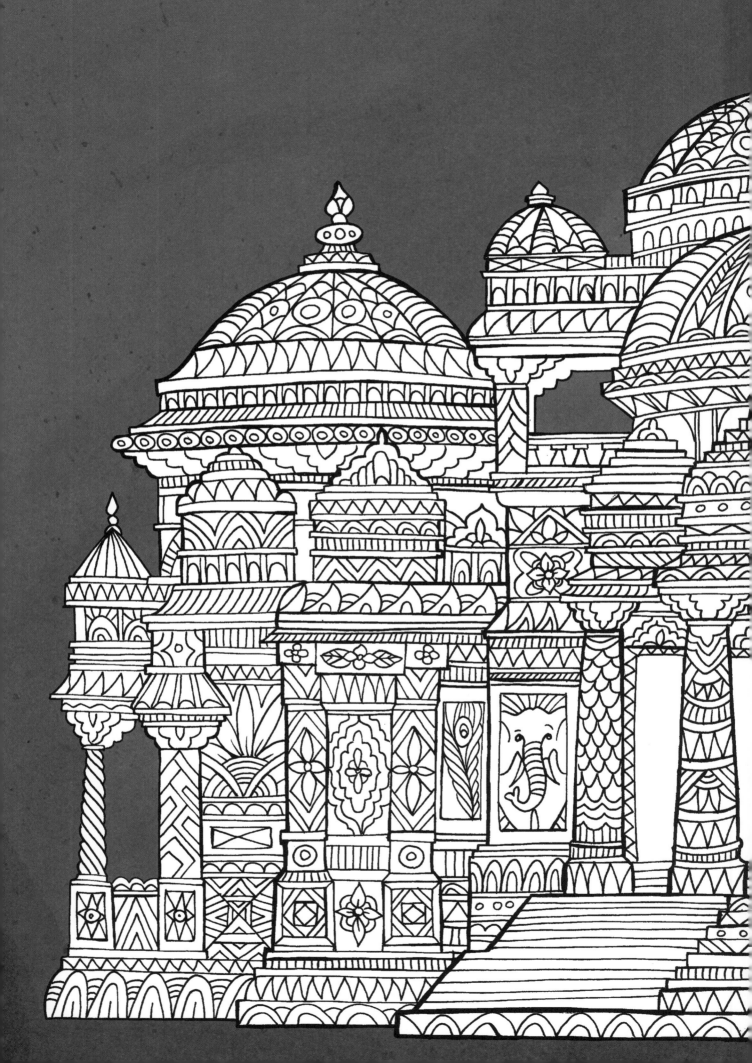

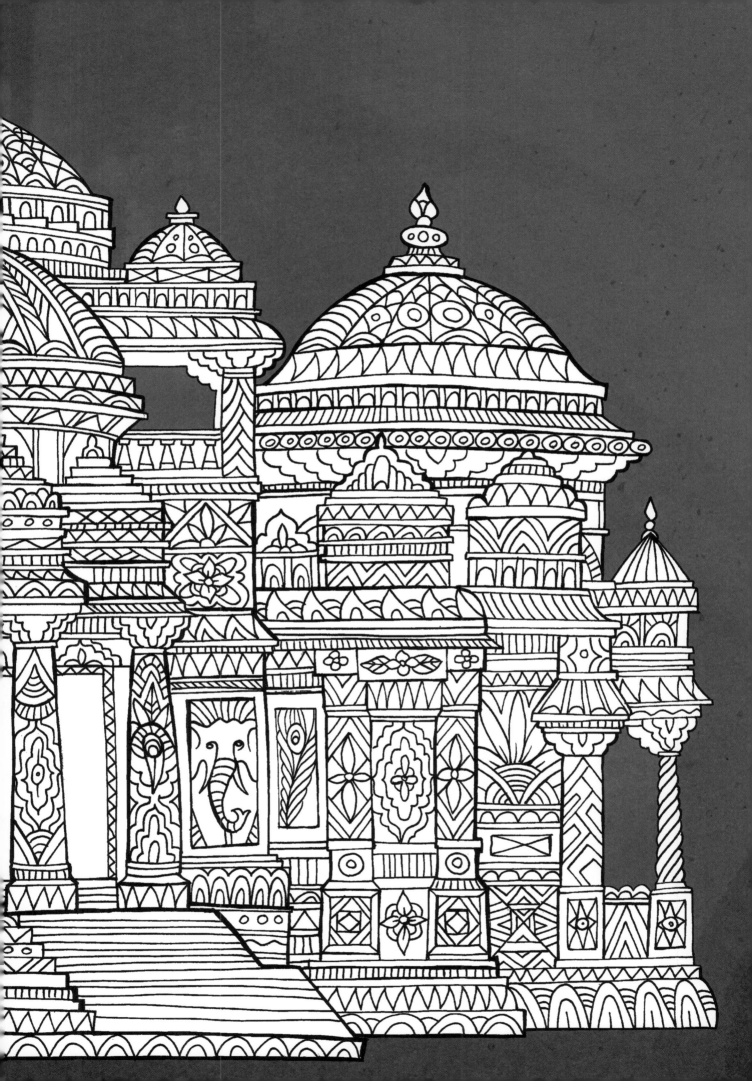

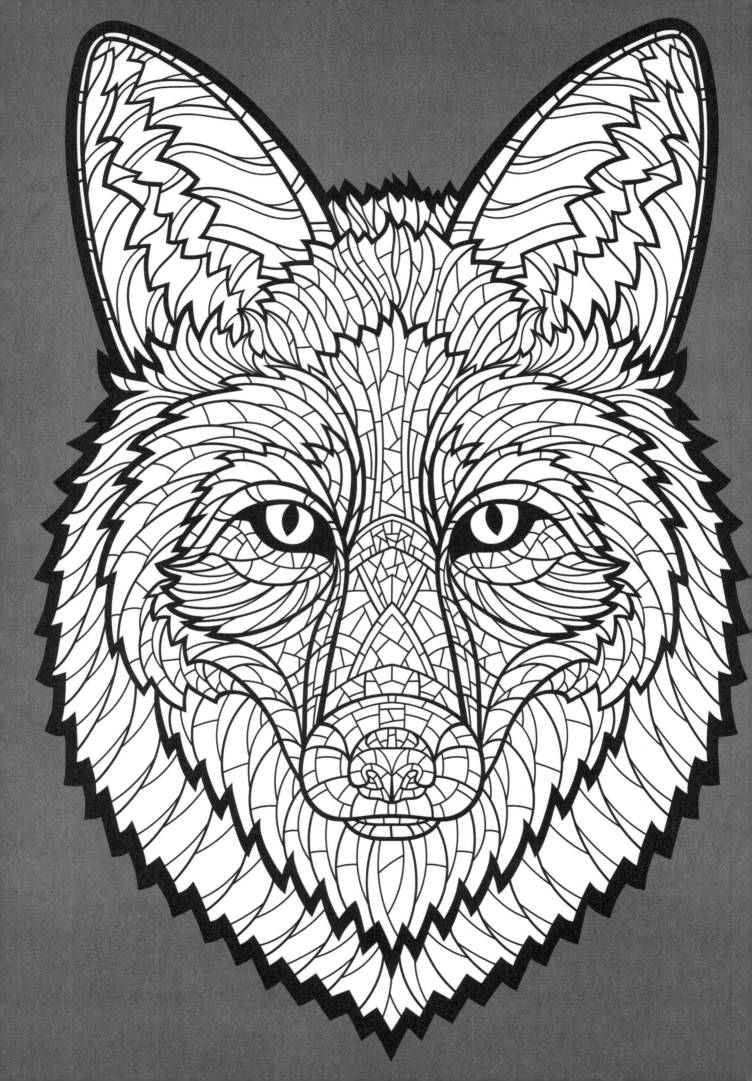

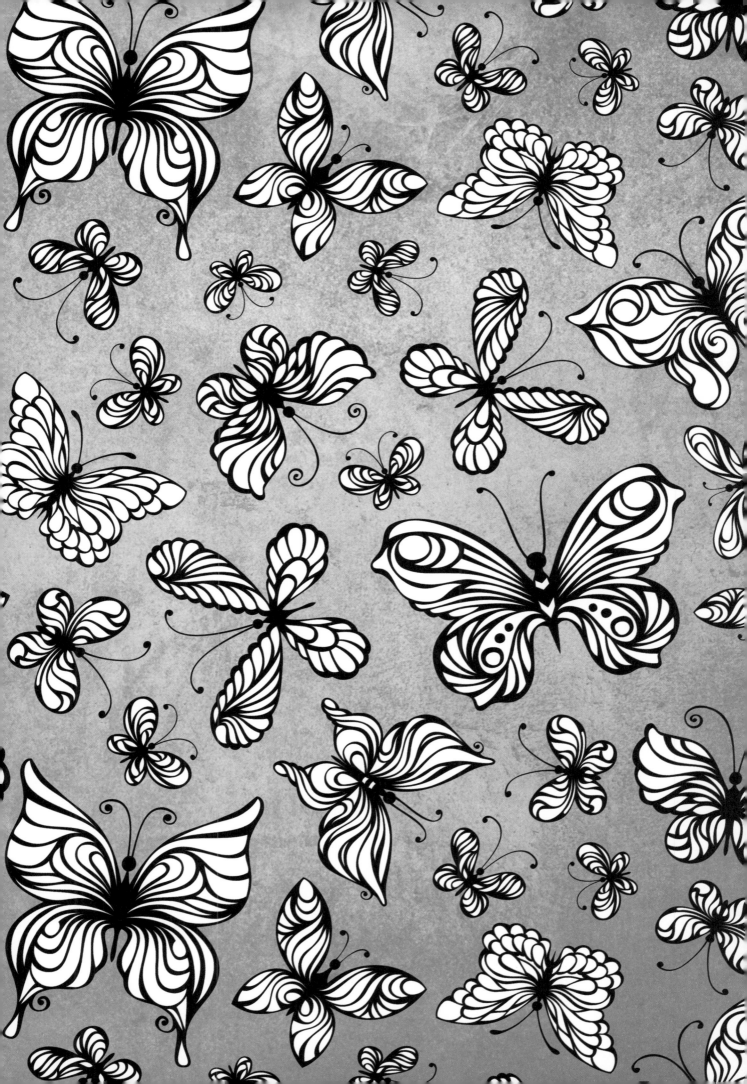

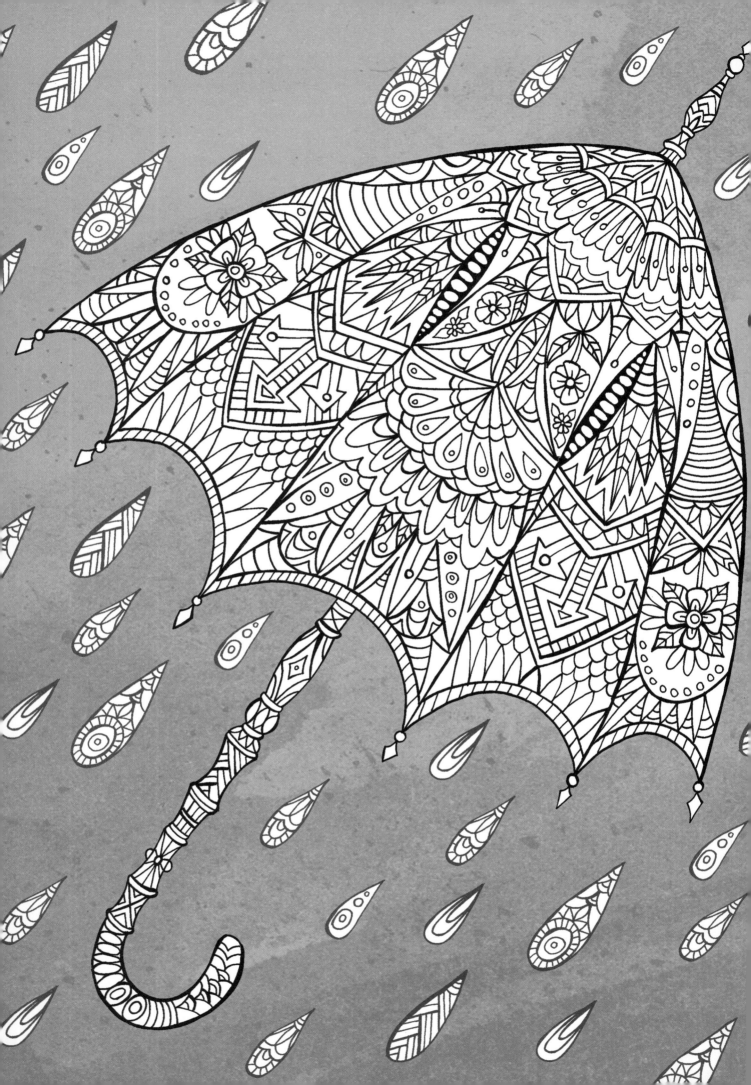

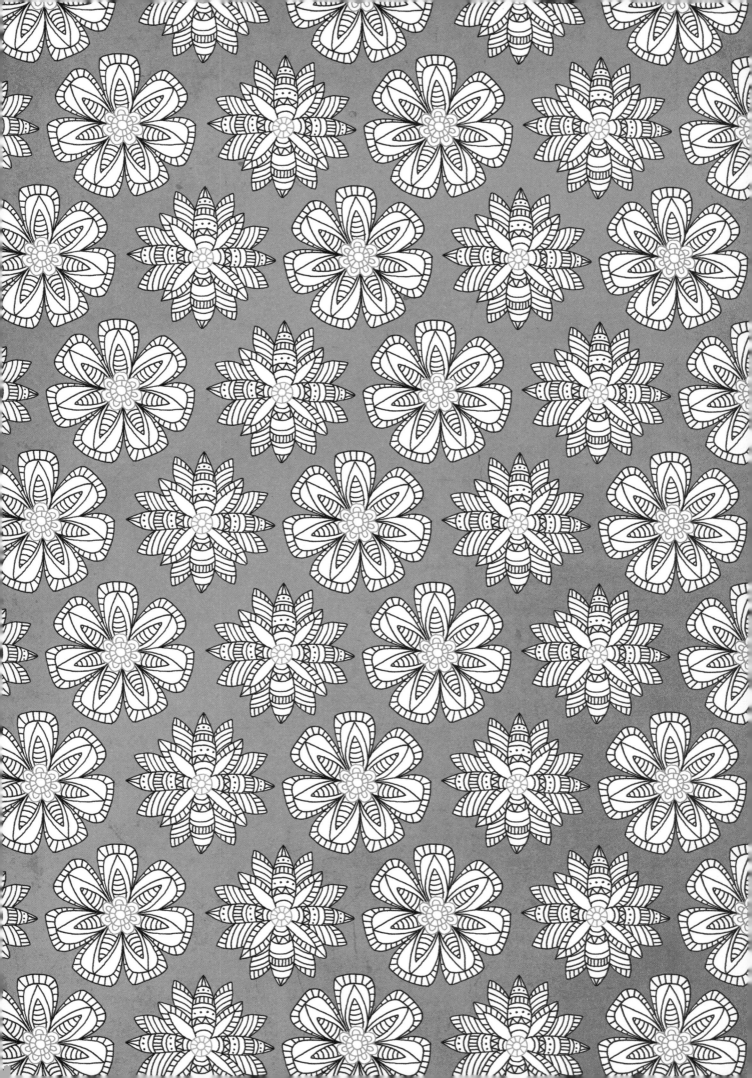

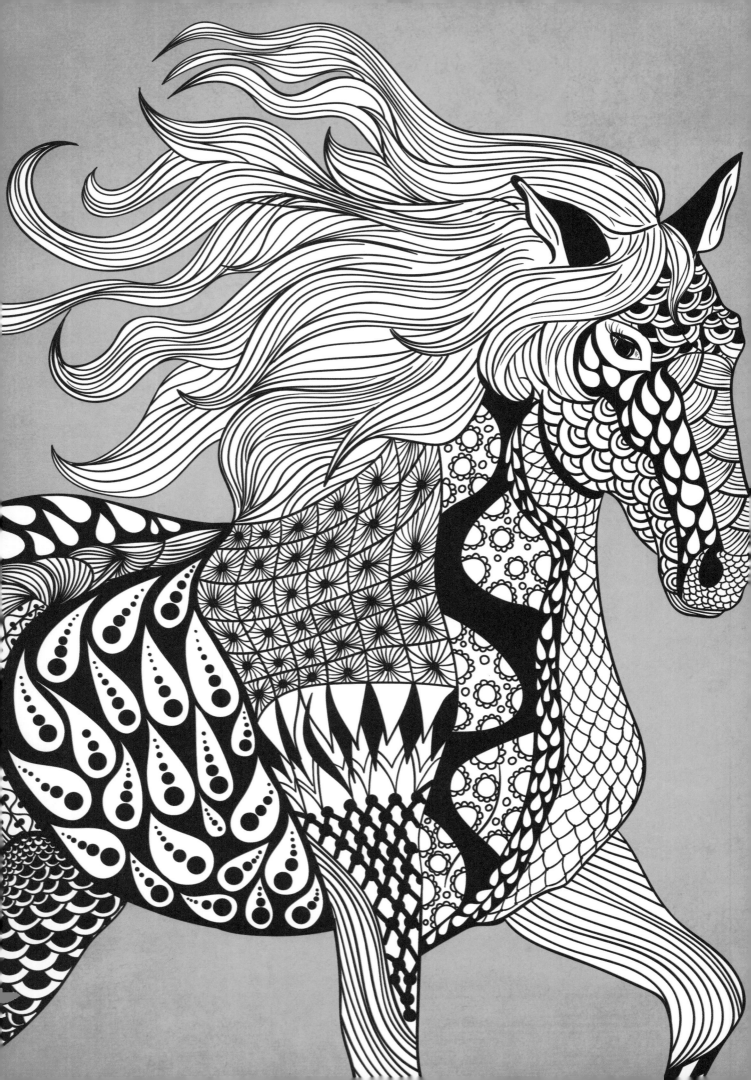

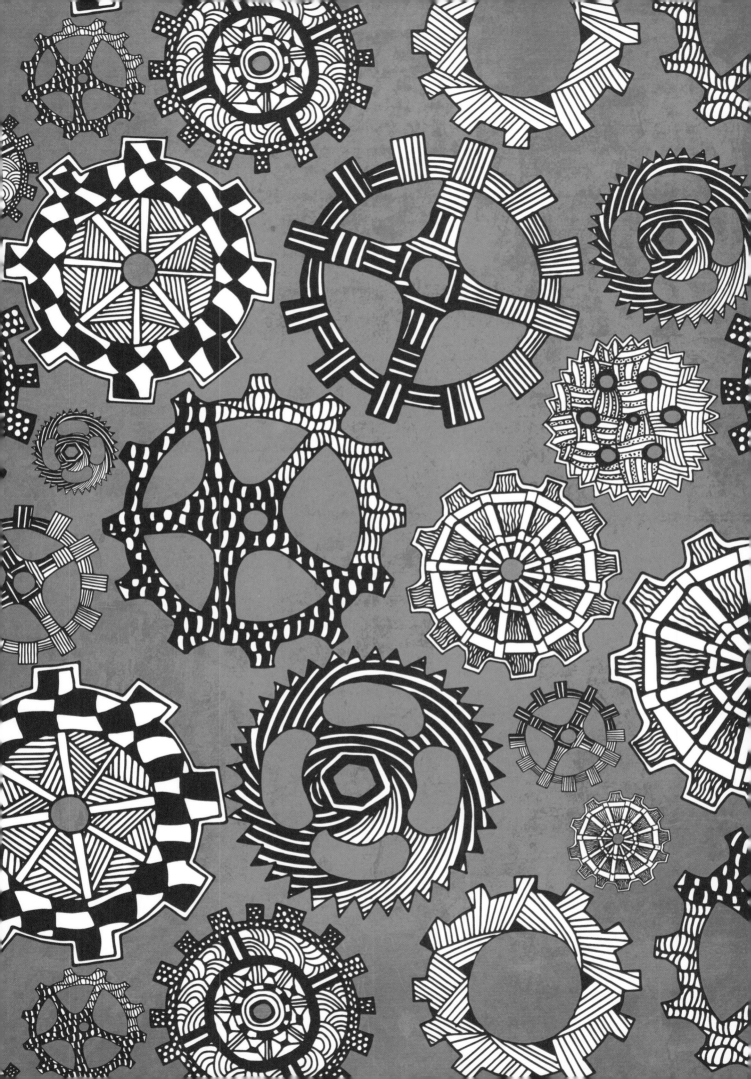

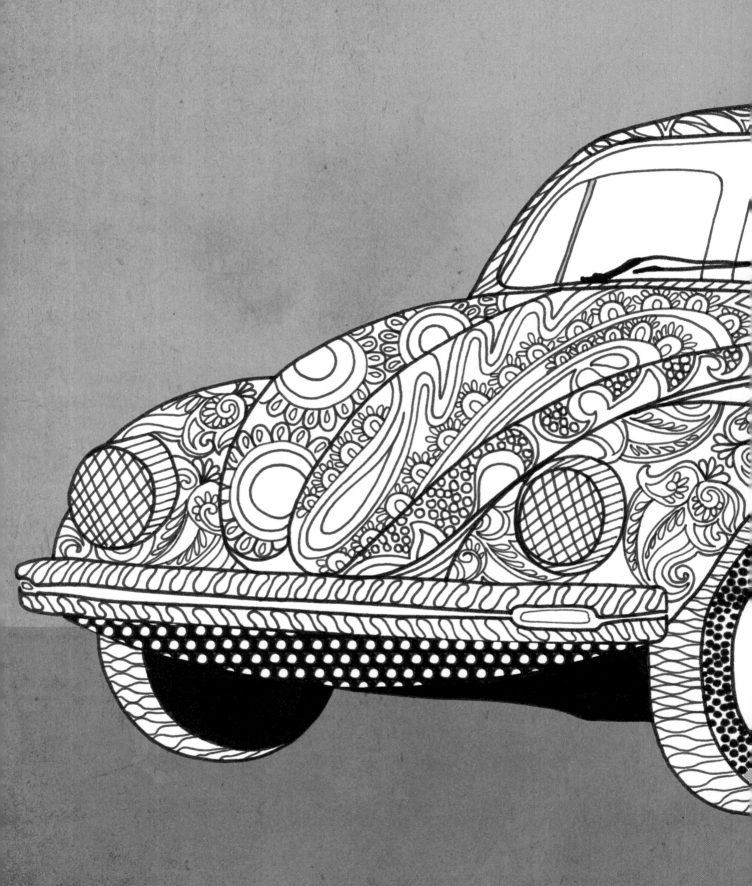

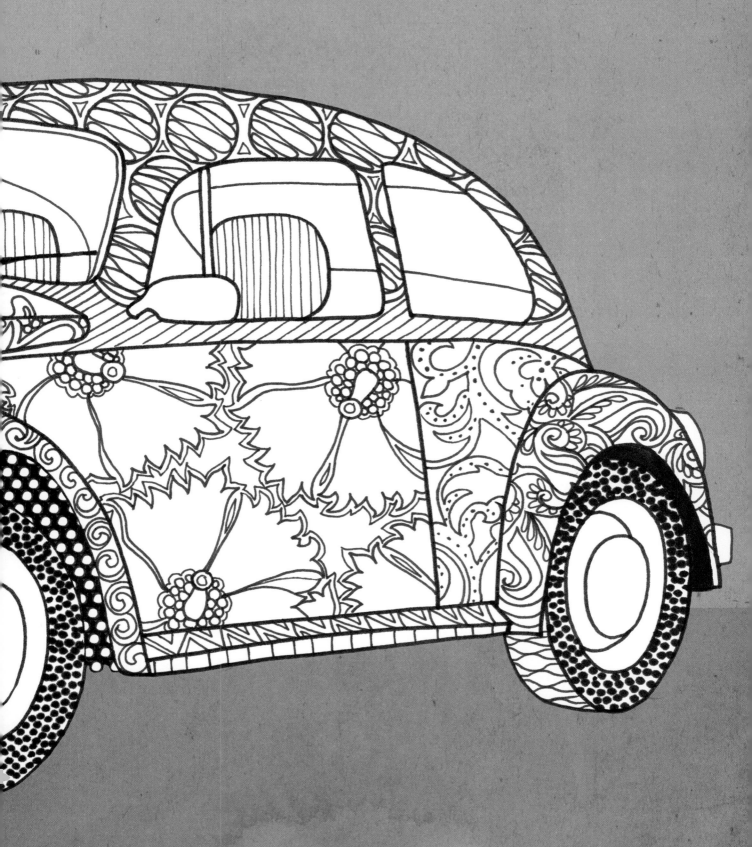

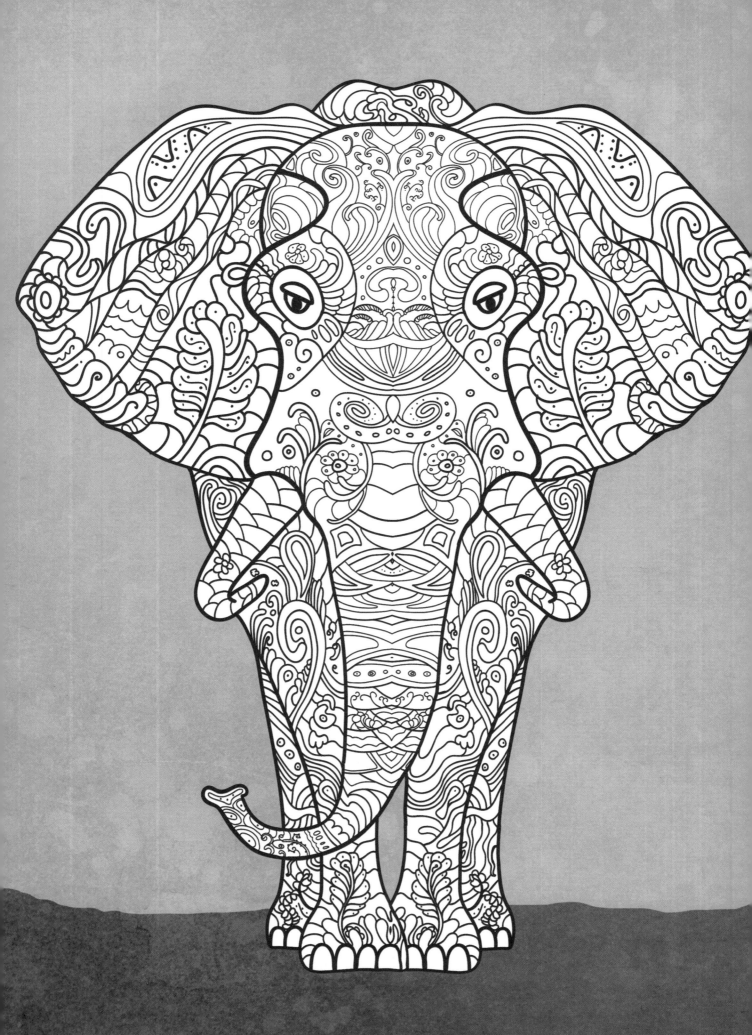

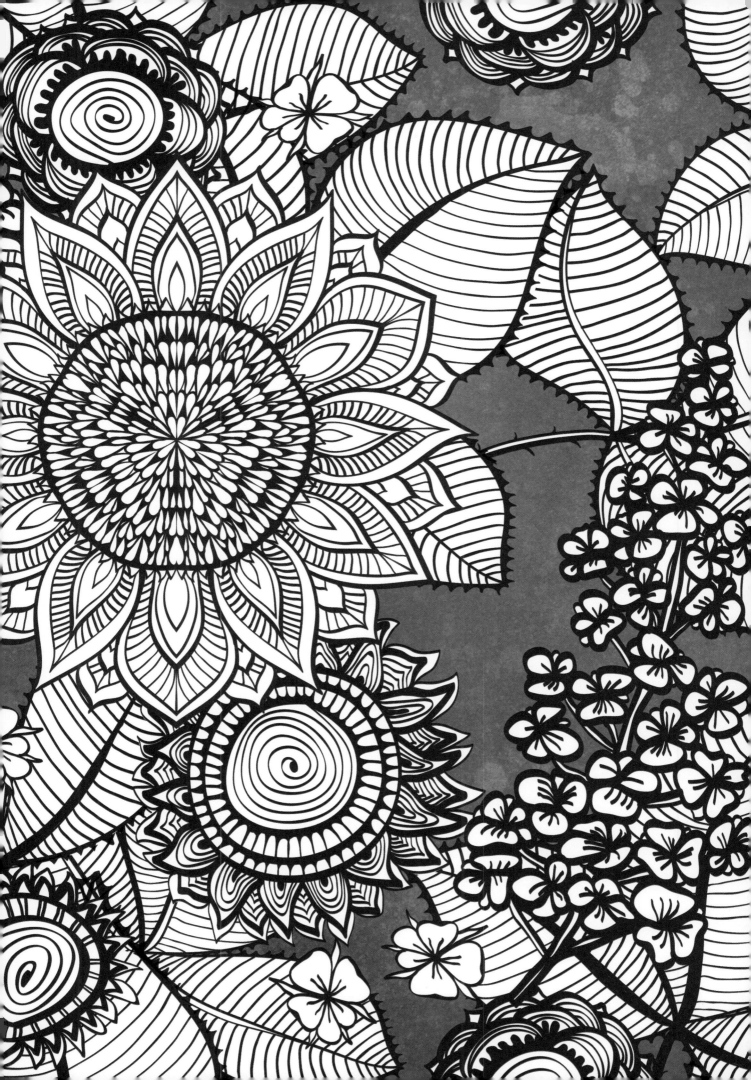

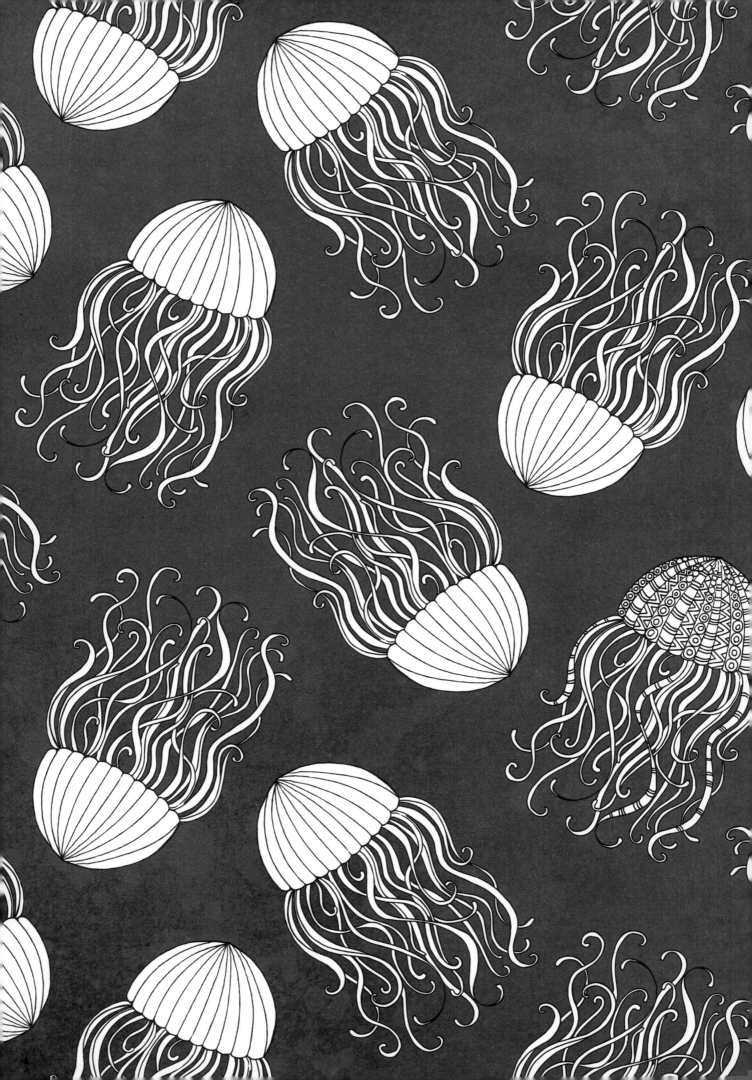

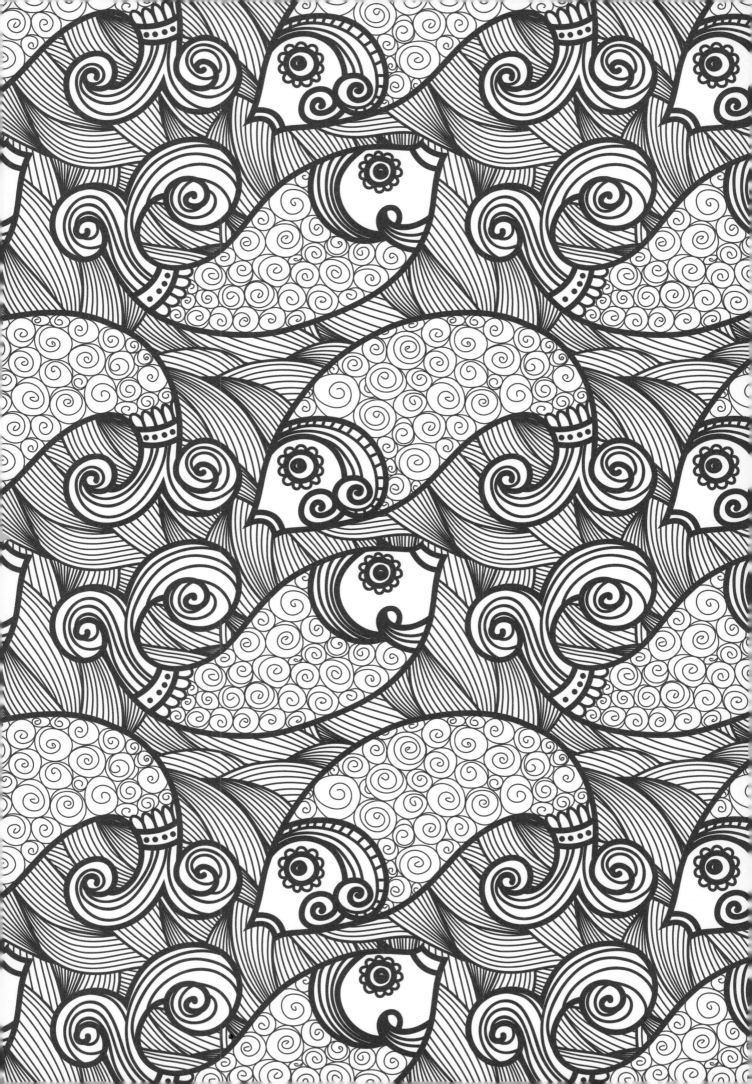

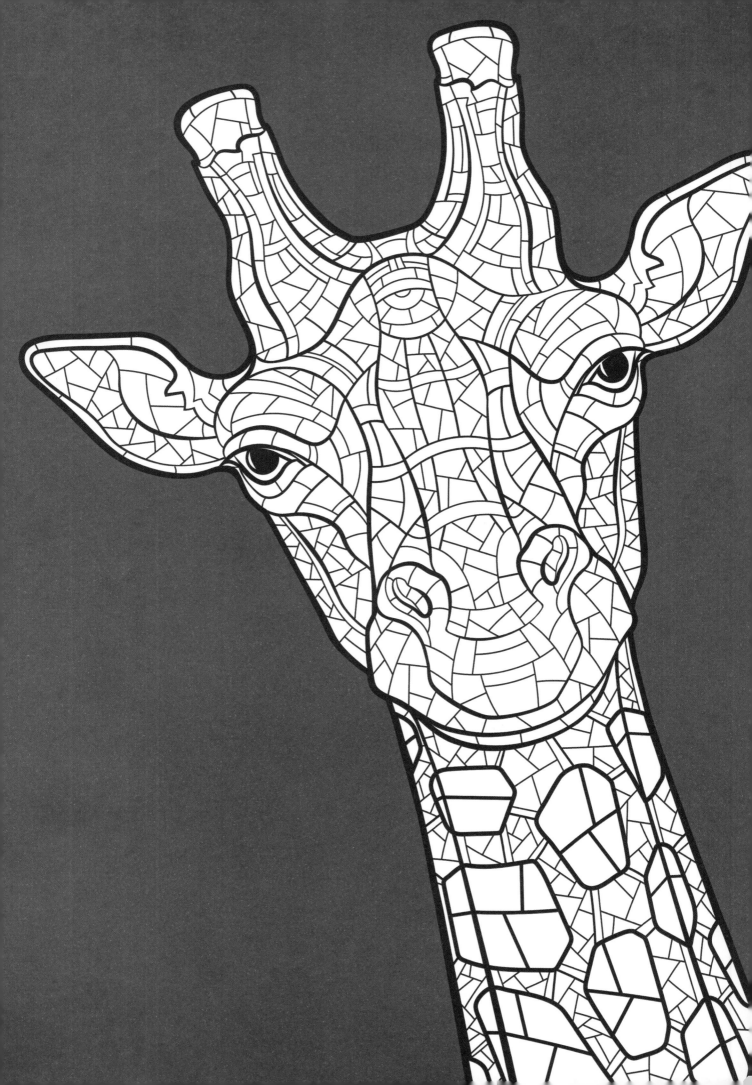

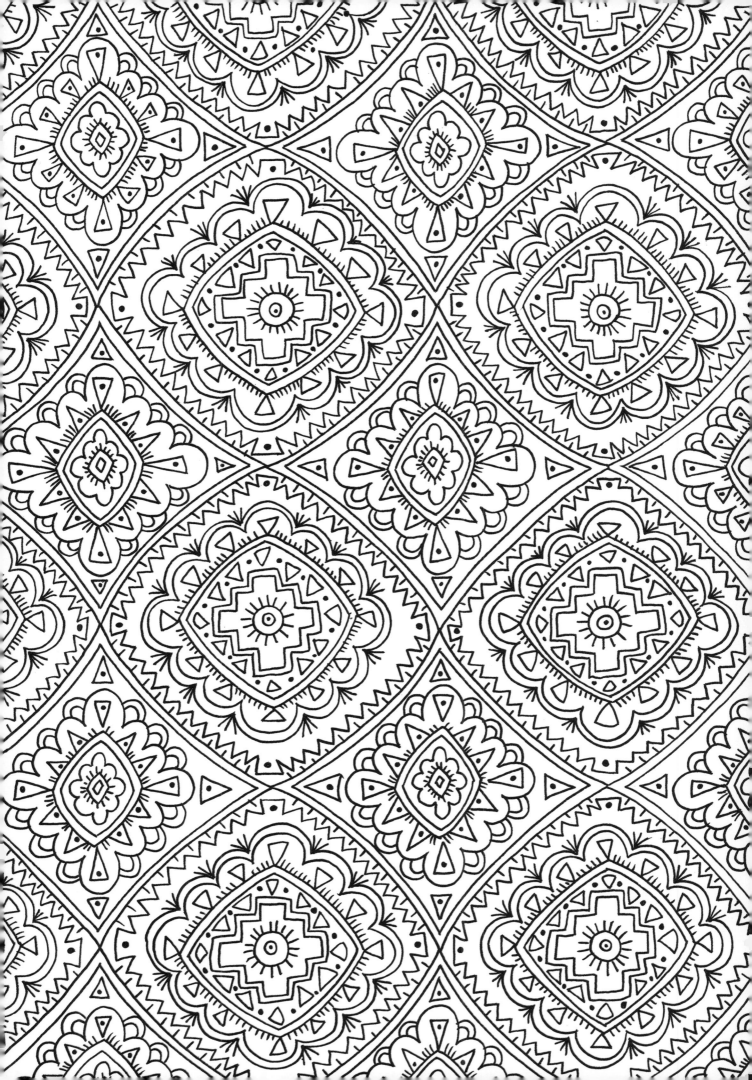

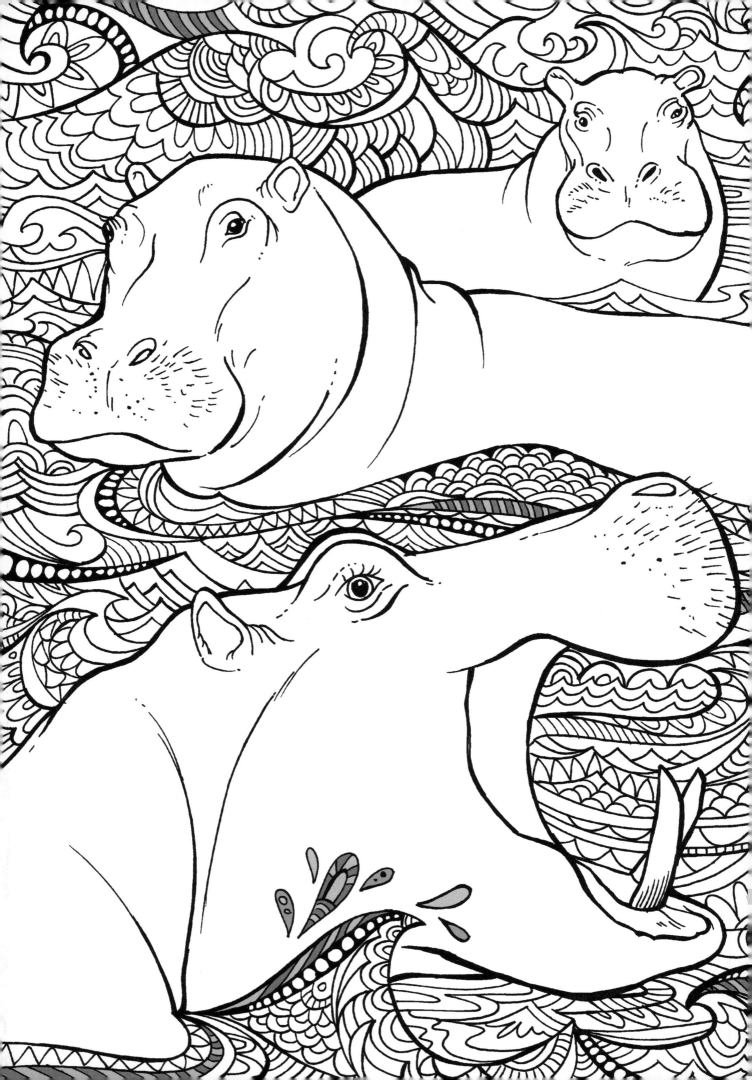

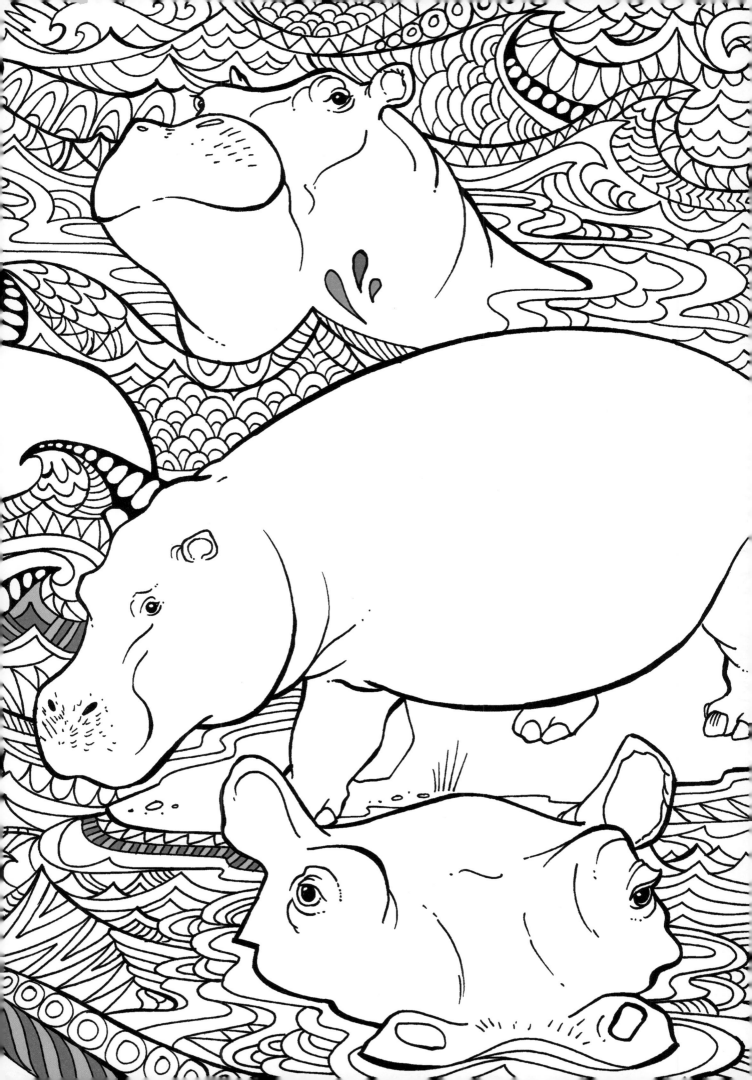

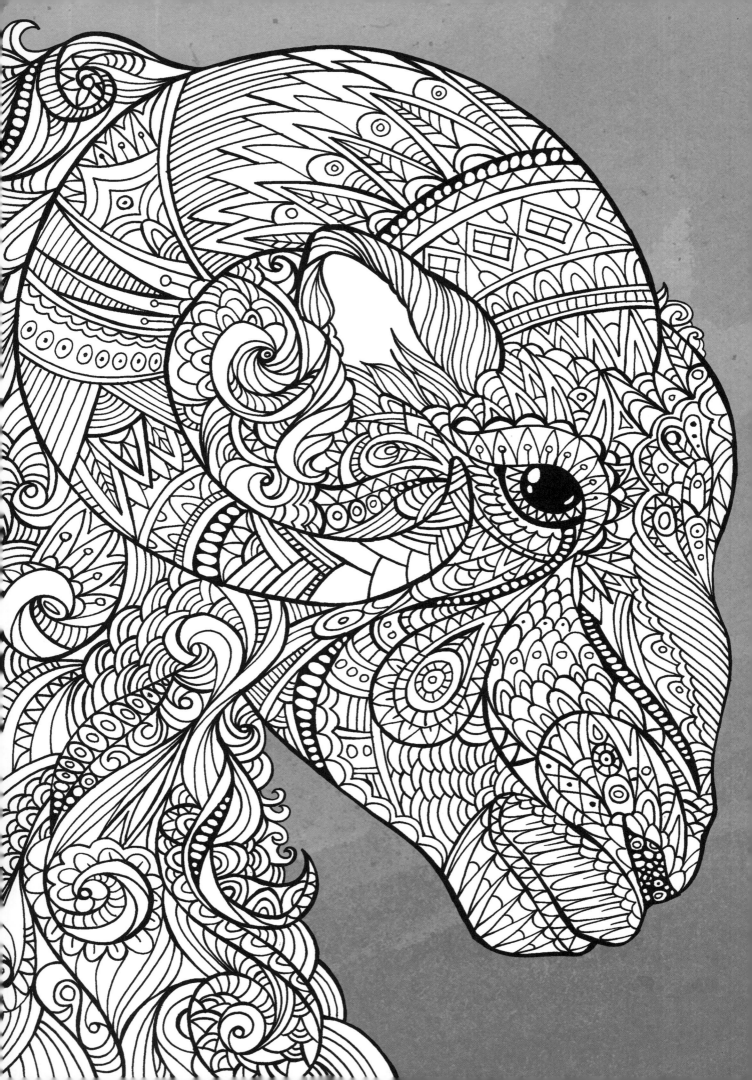

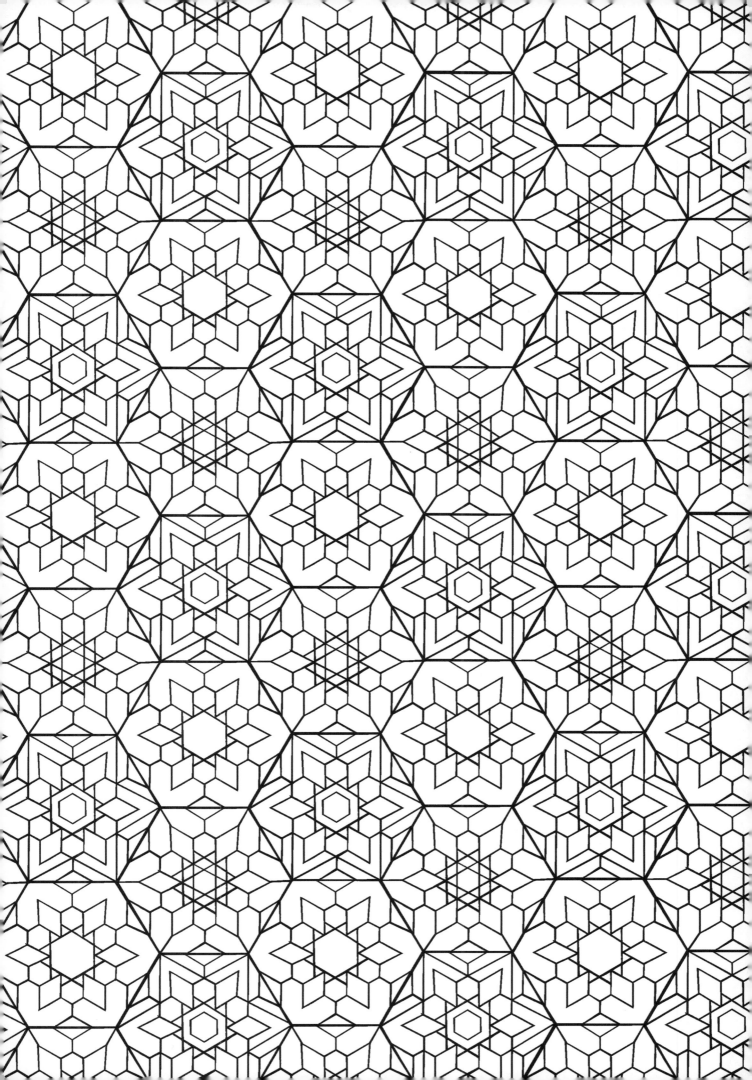

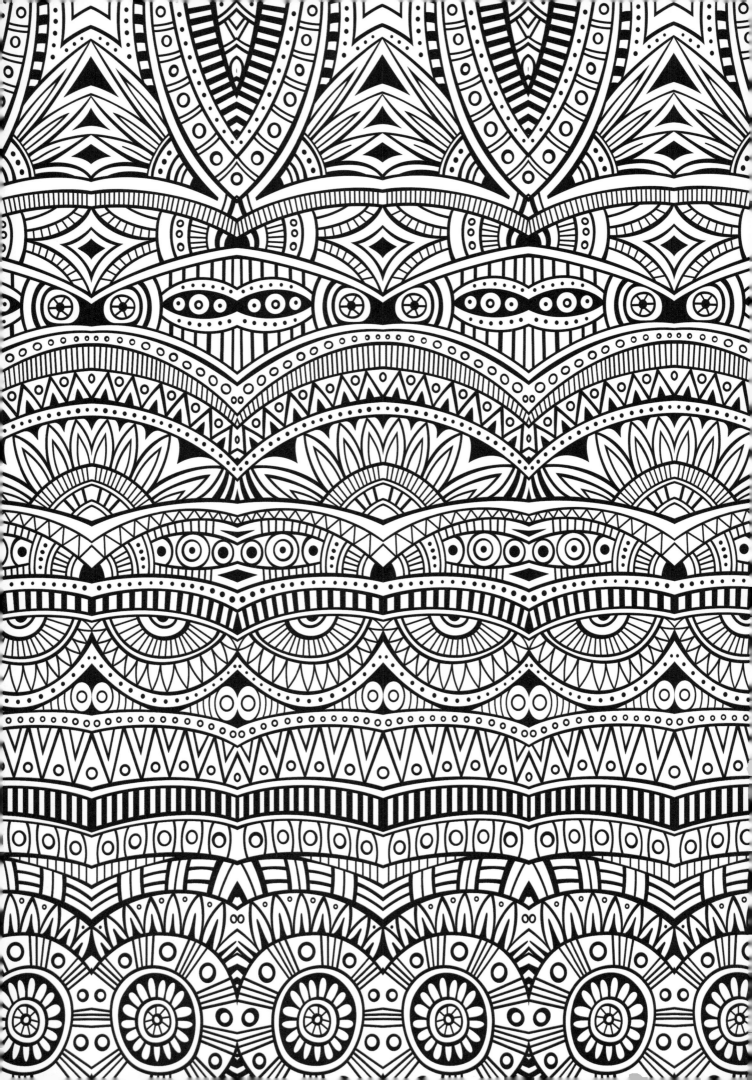

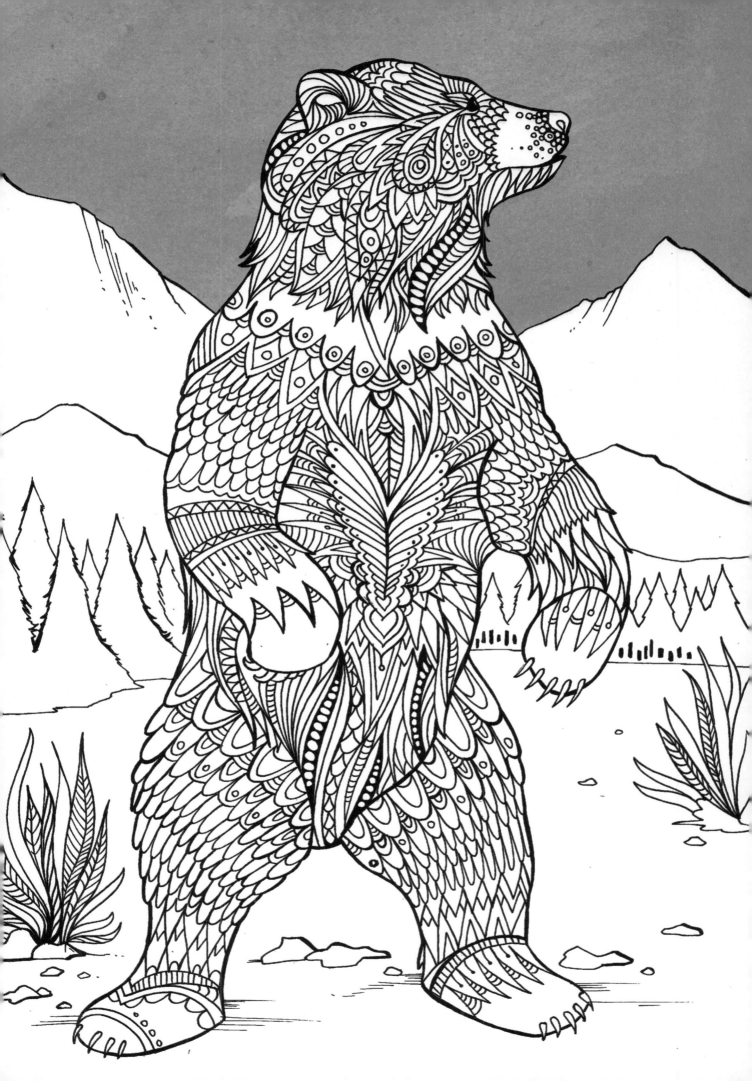

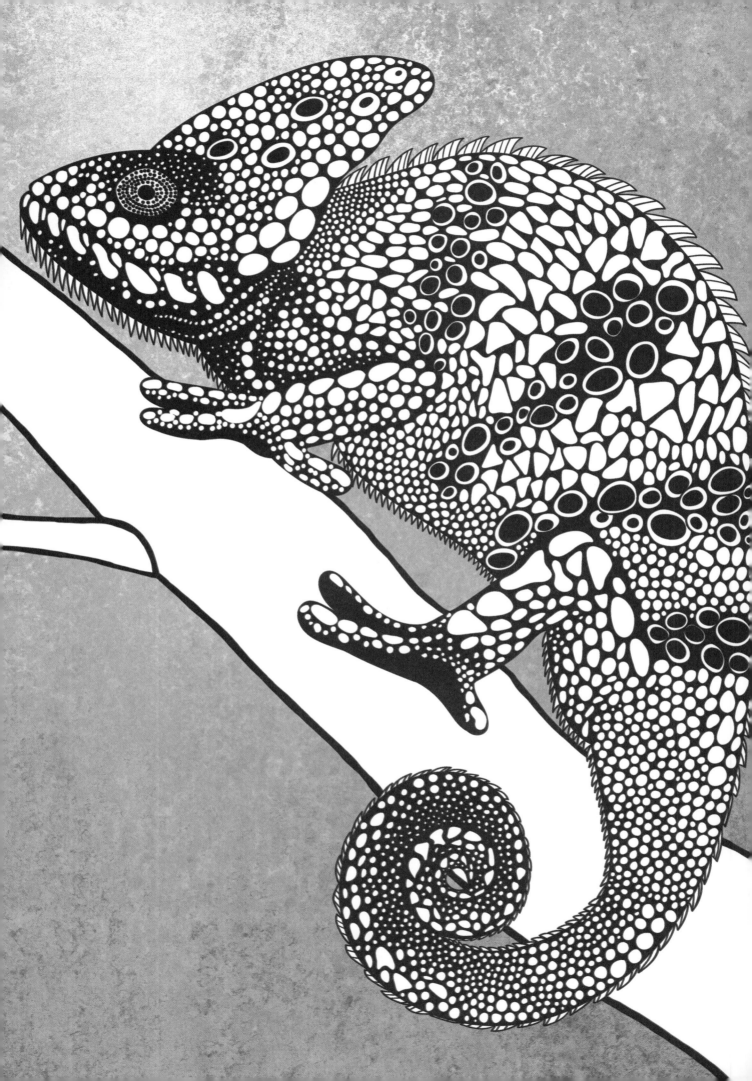

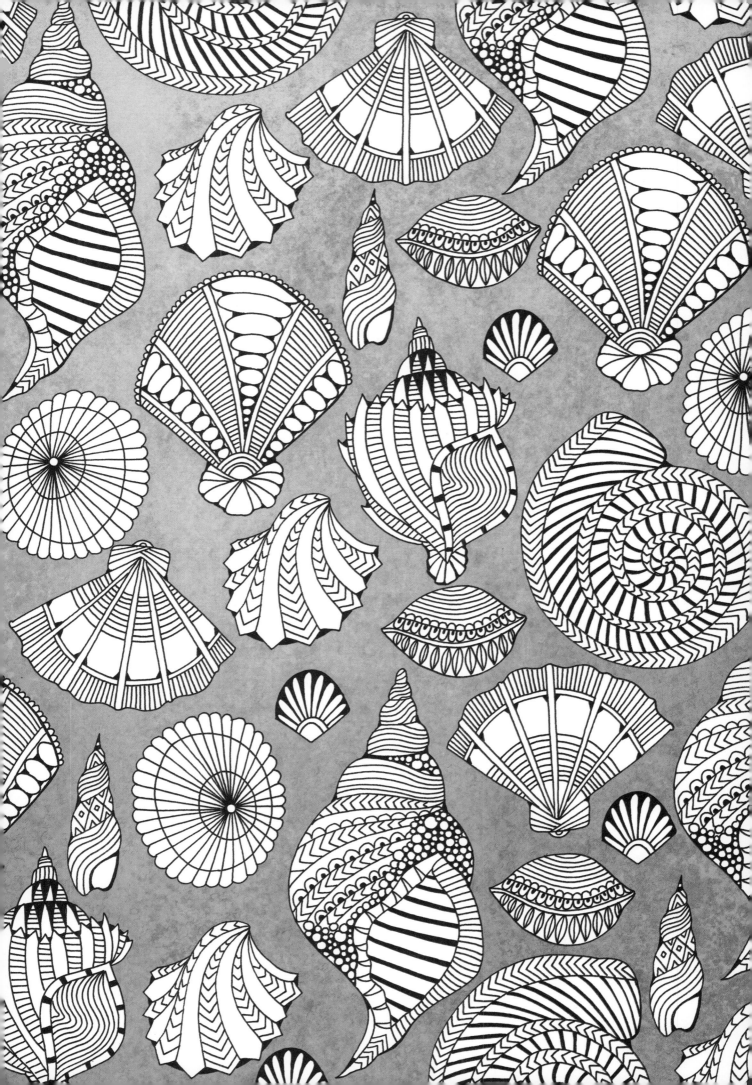

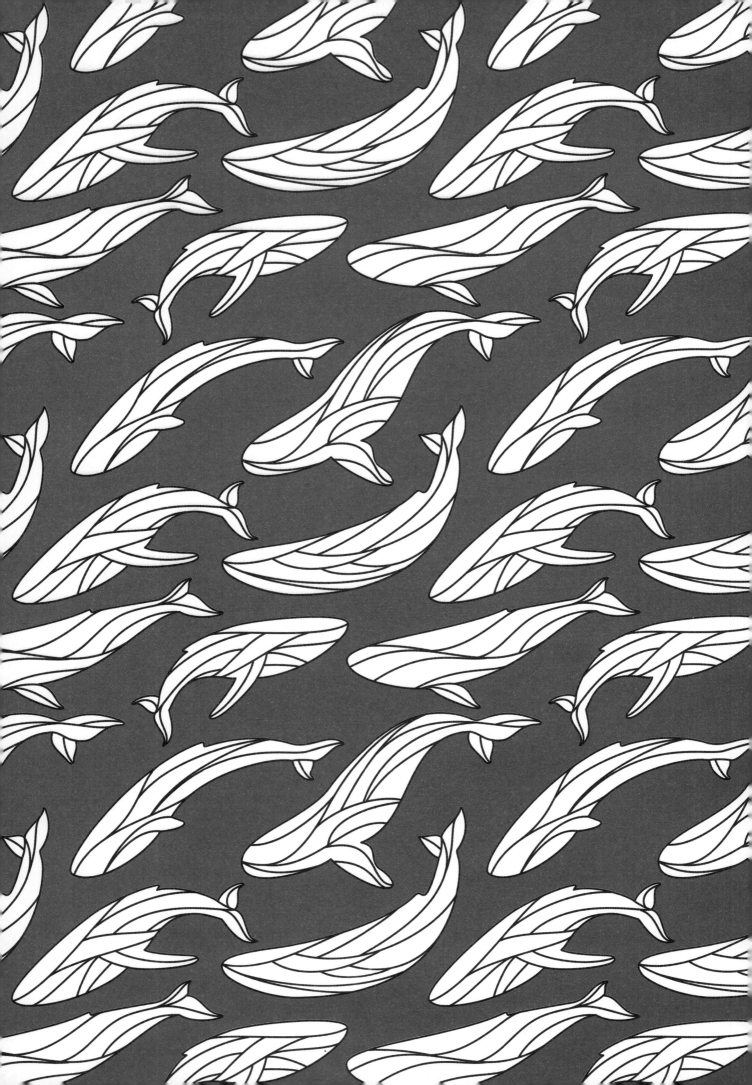

DOODLING

Complete the patterns, finish the animals, and draw some
delights in this creative doodling section. You can use circles,
swirls, zigzags and lines—there is no right or wrong.
So pick up your coloring pens or pencils and
let your imagination run free.

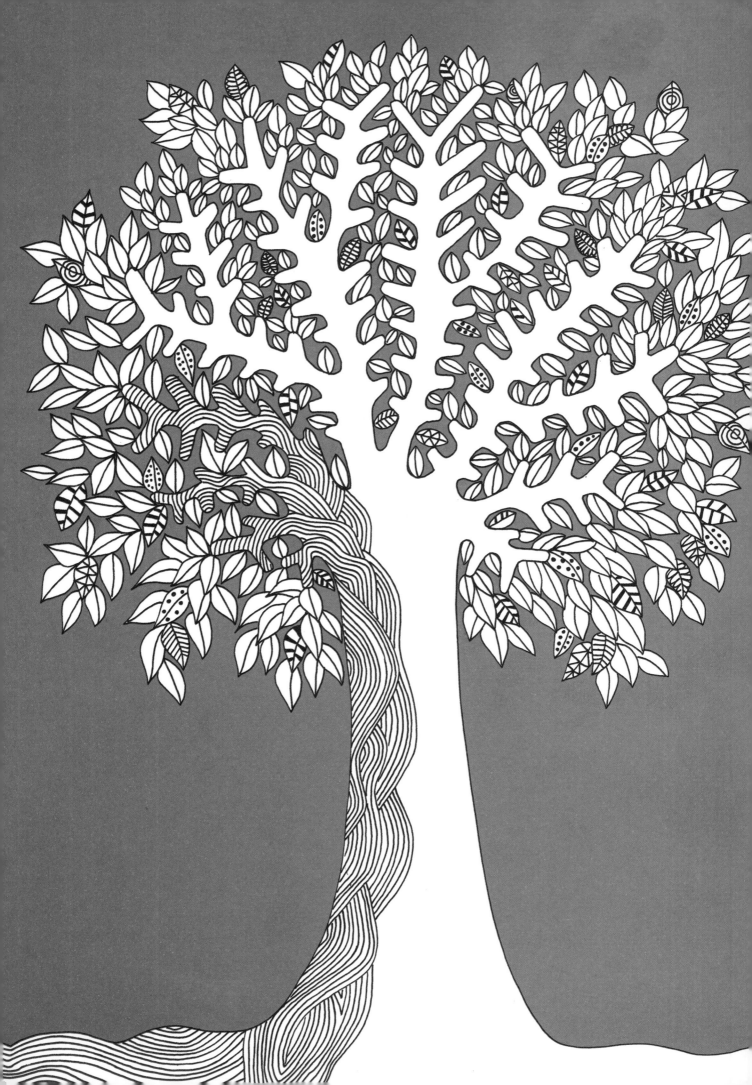

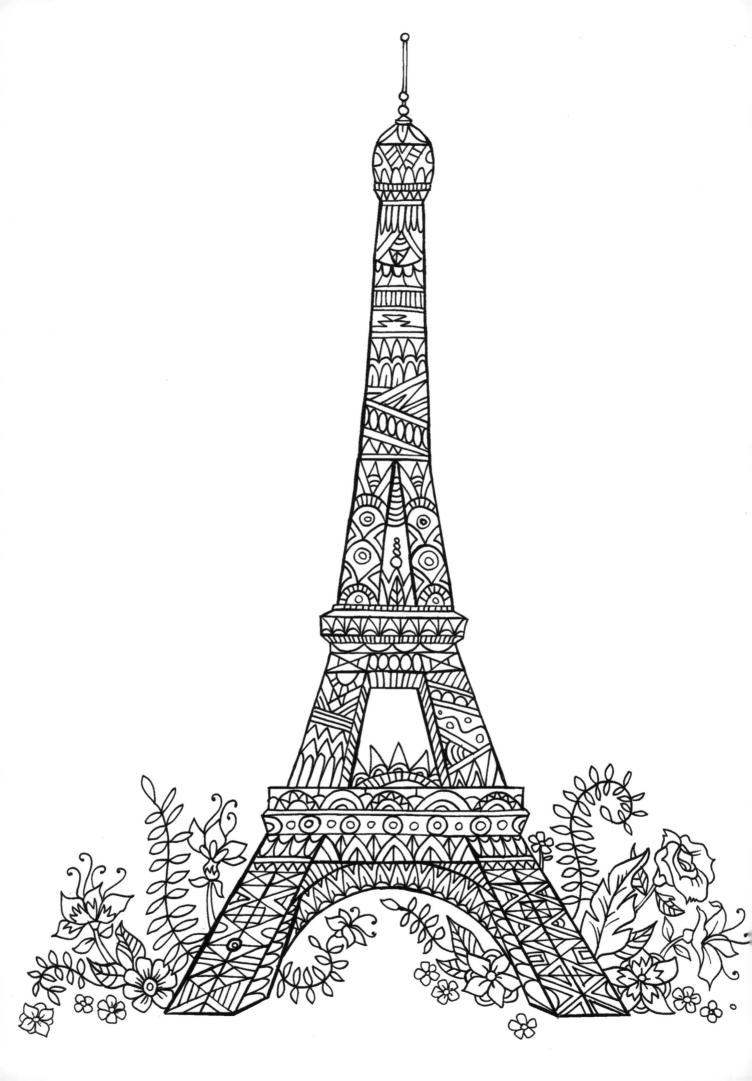

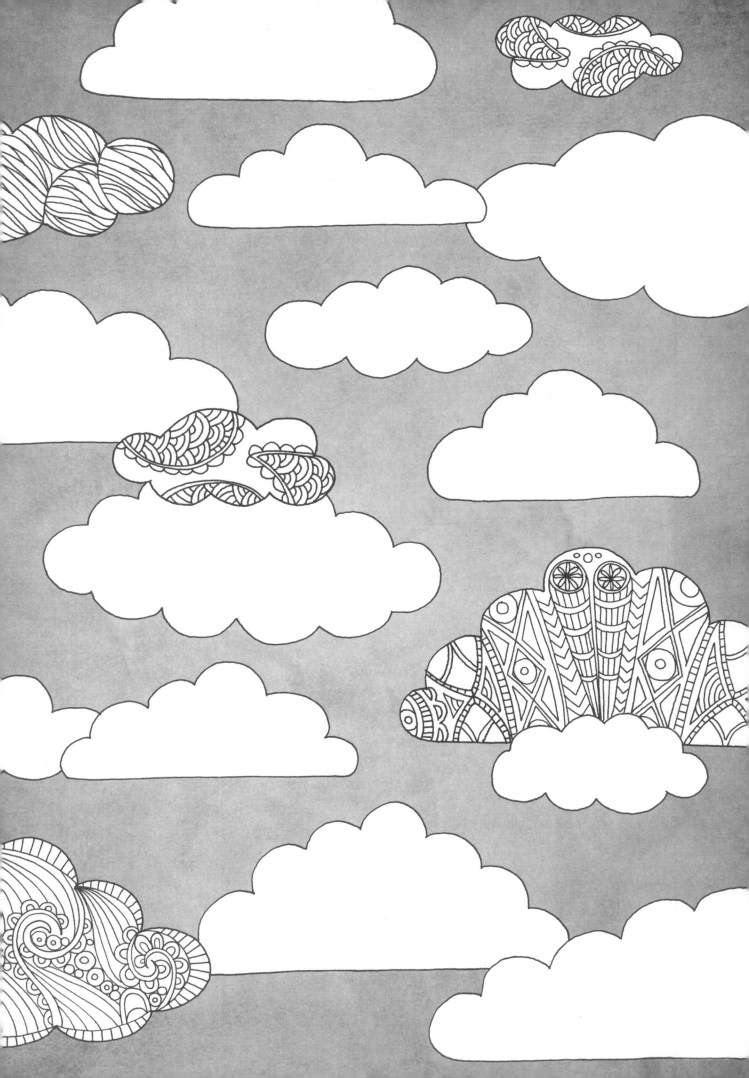

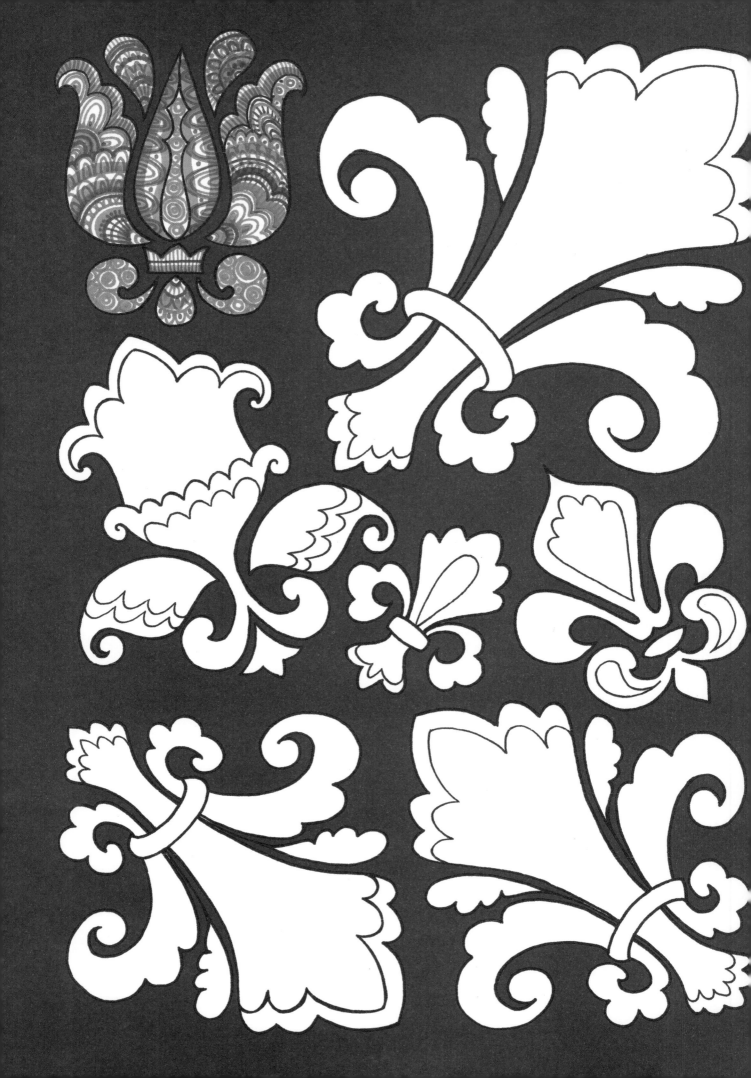

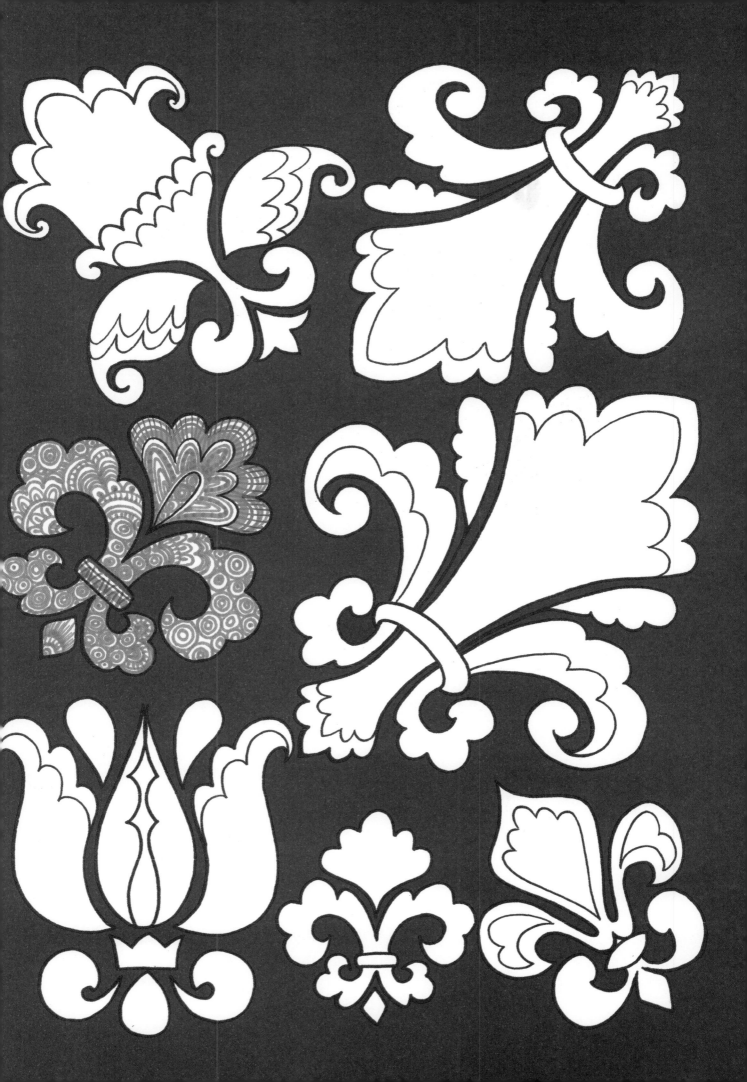

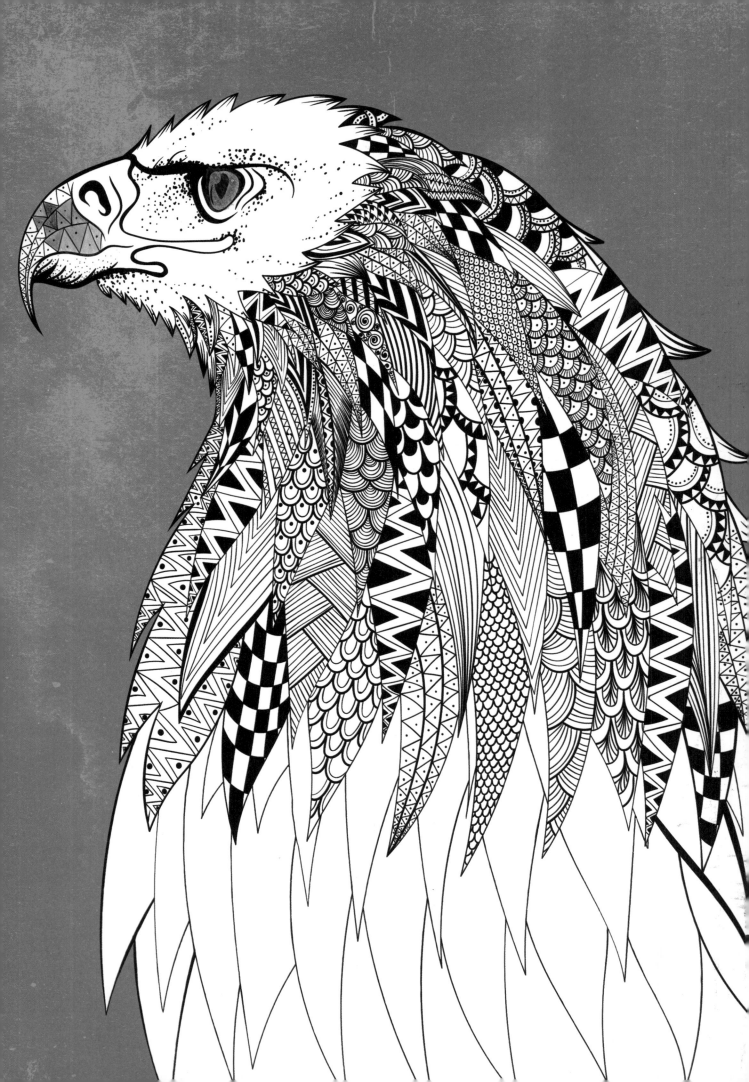

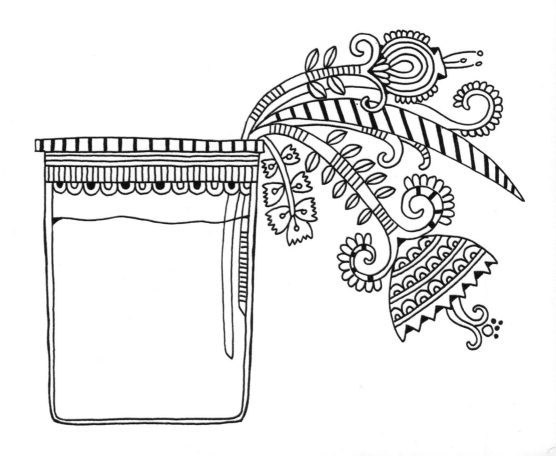

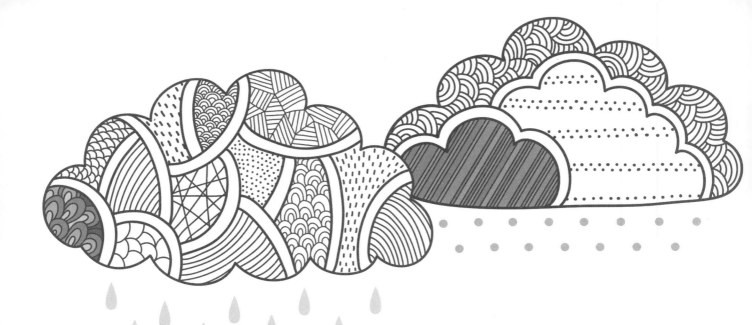

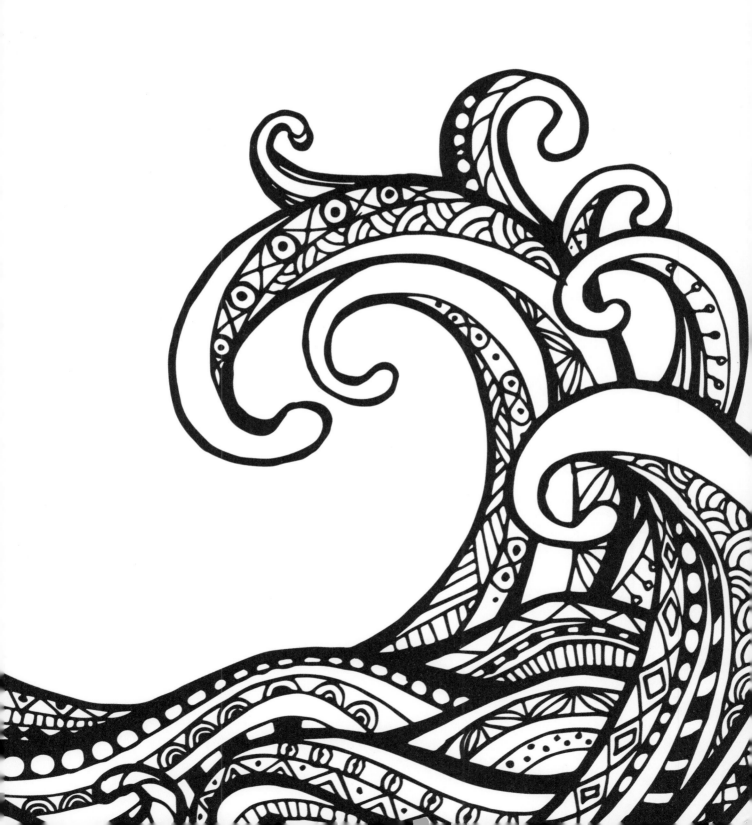

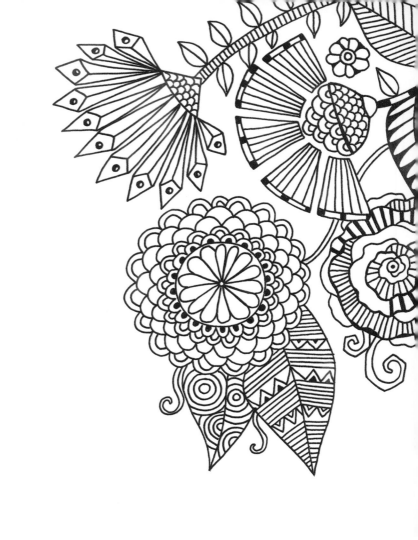
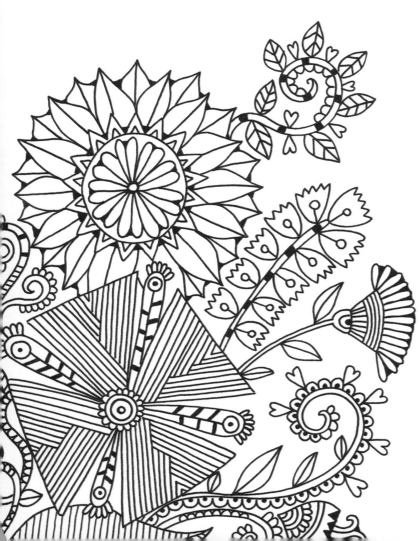

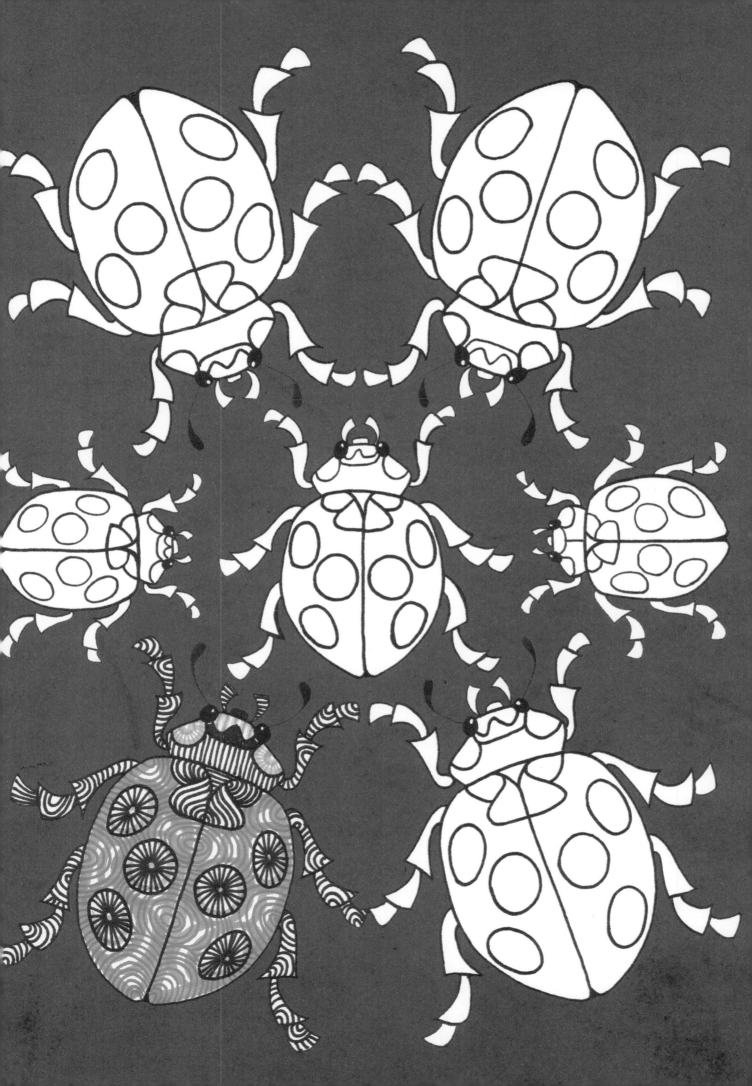

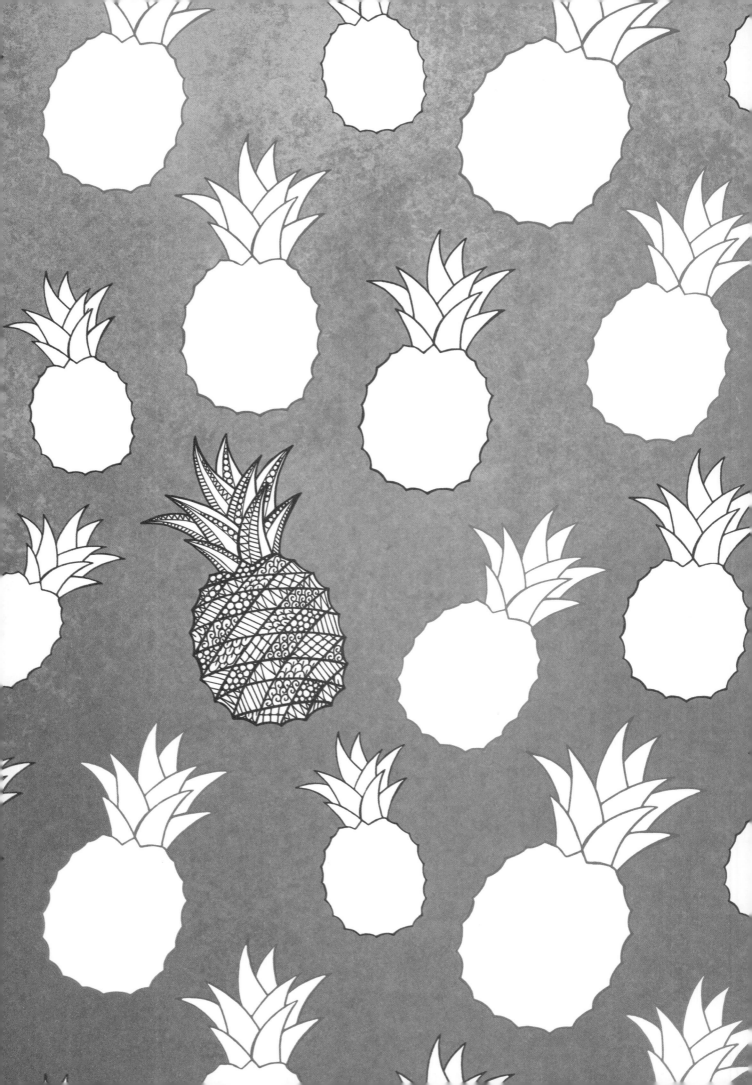

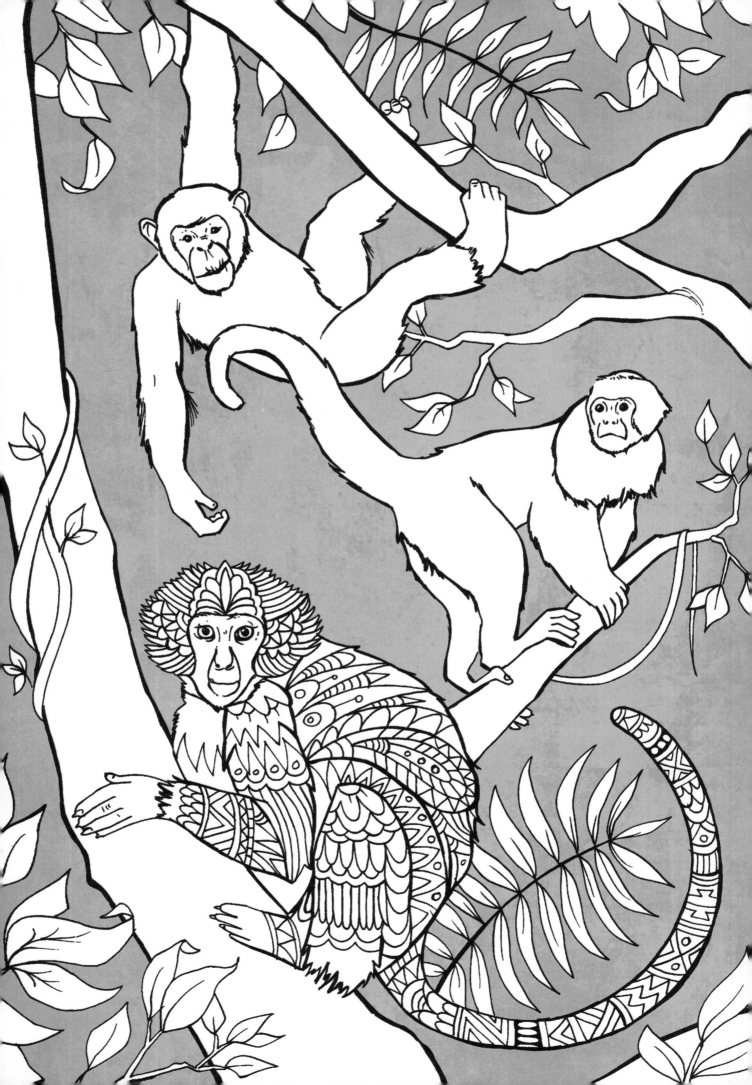

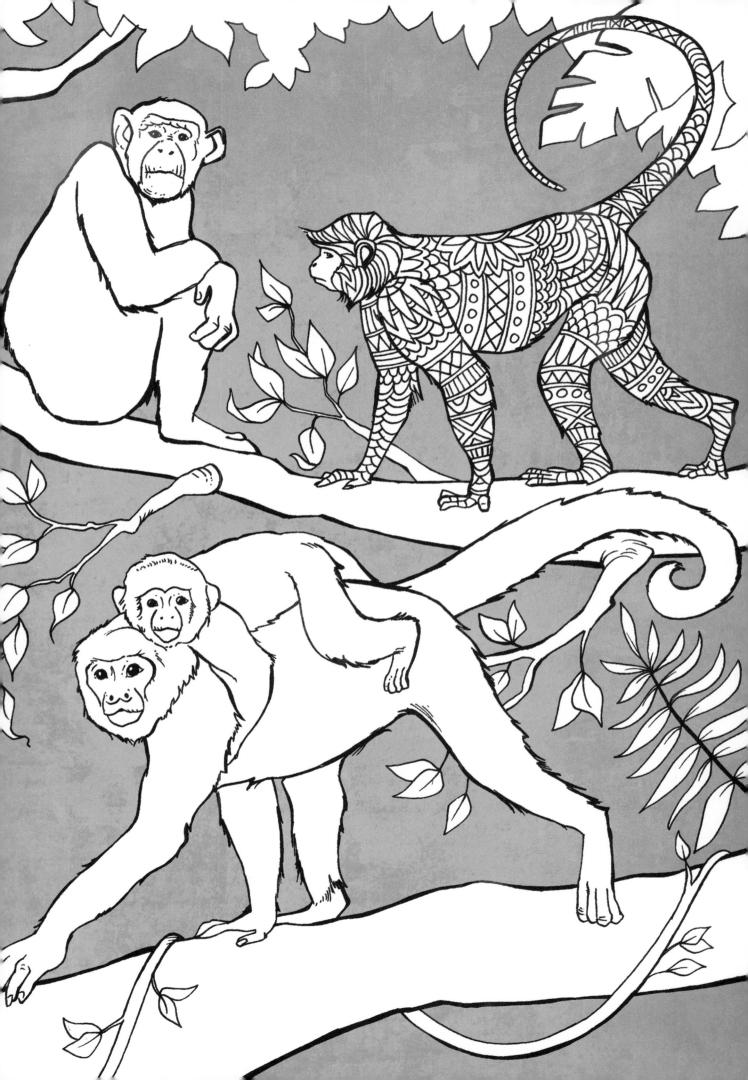

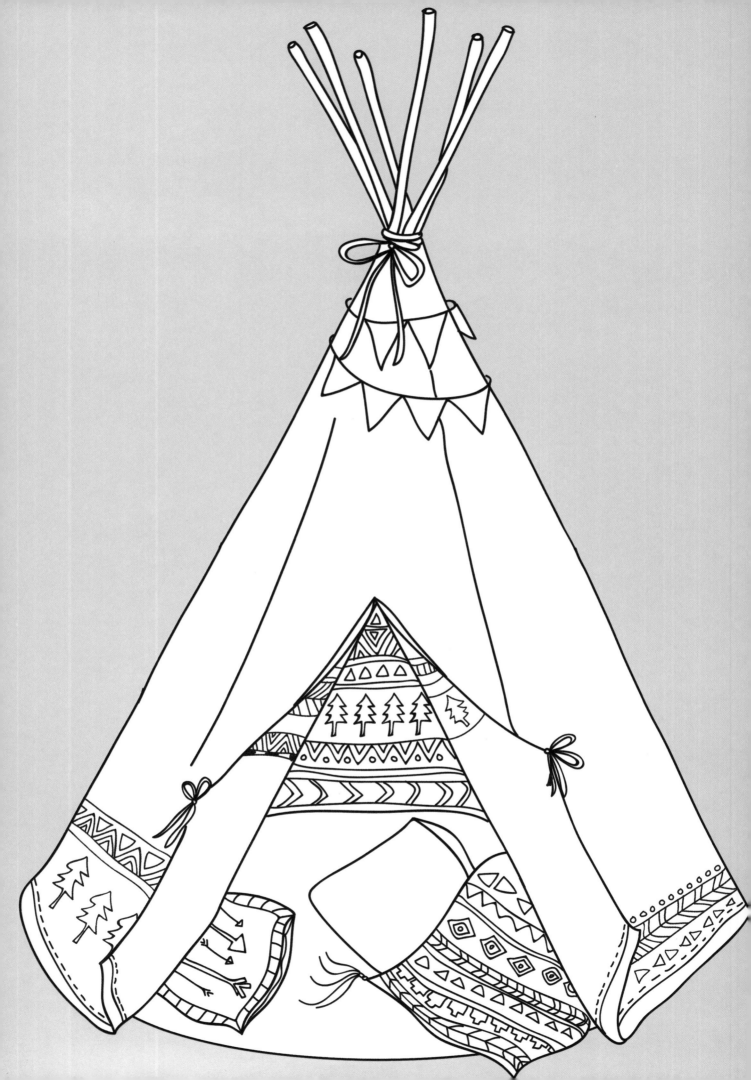

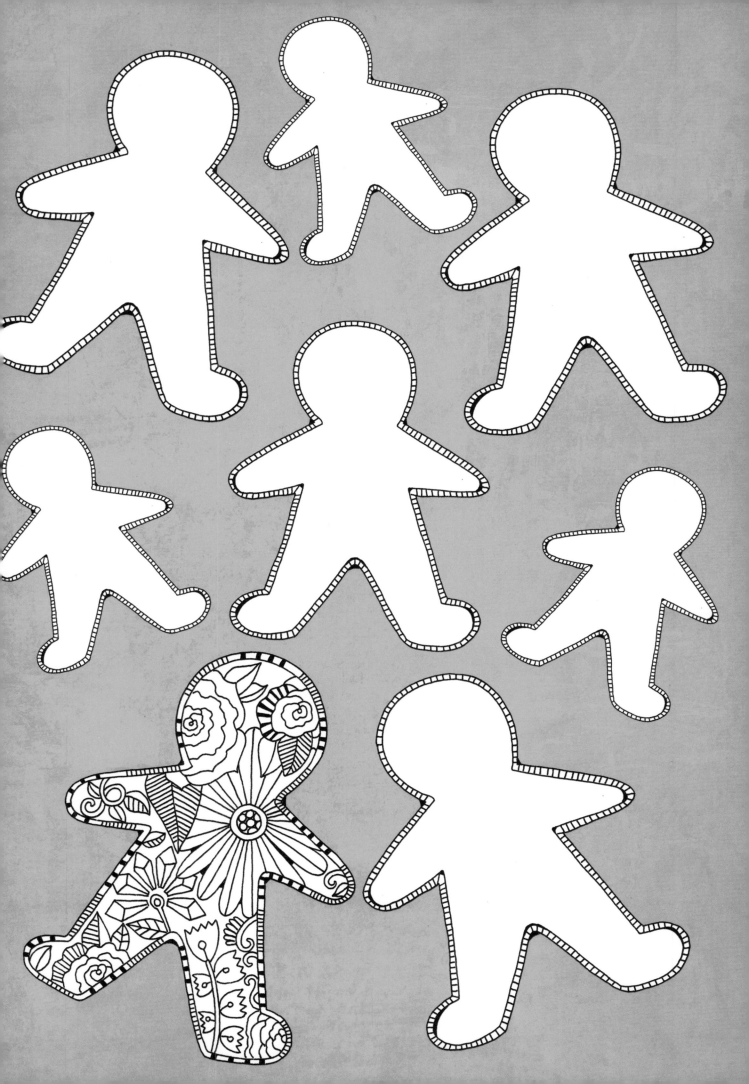

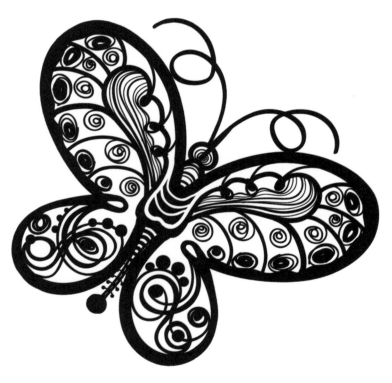
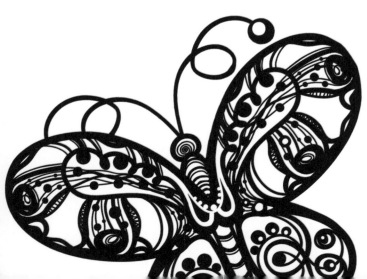

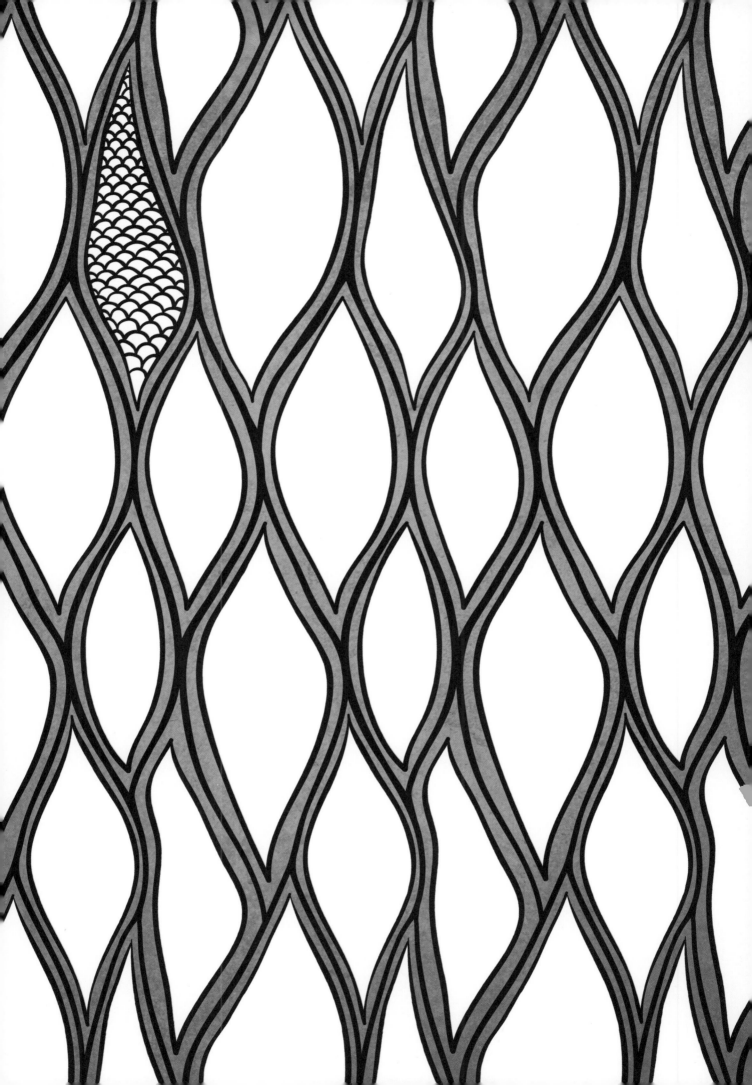

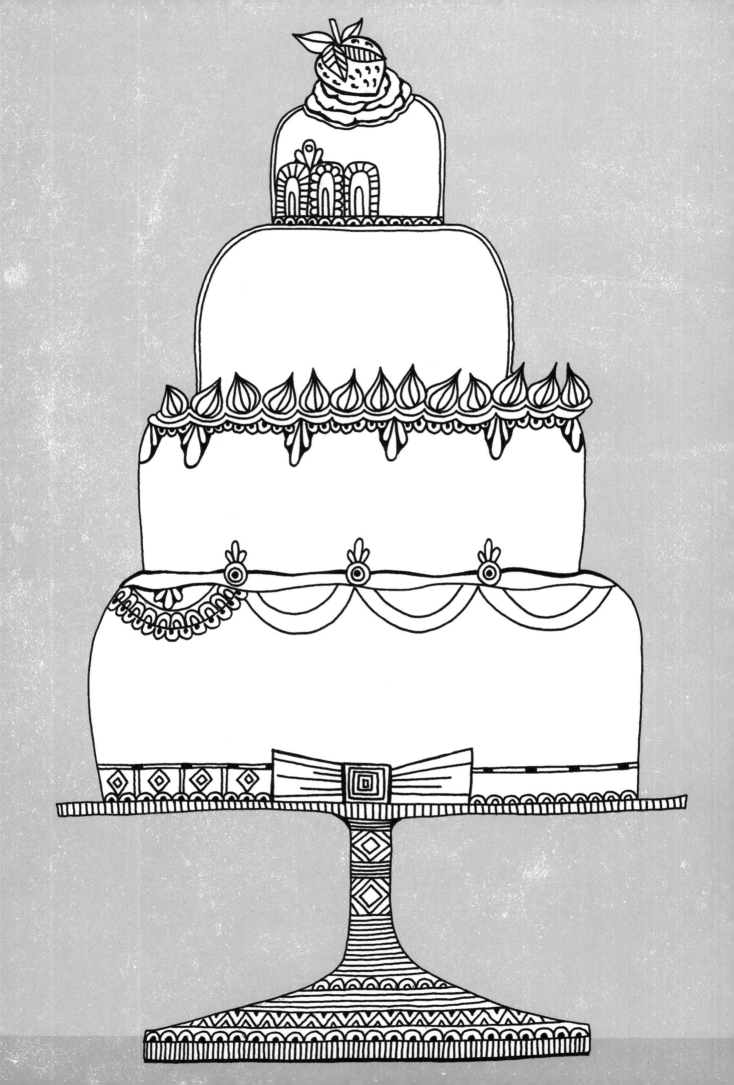

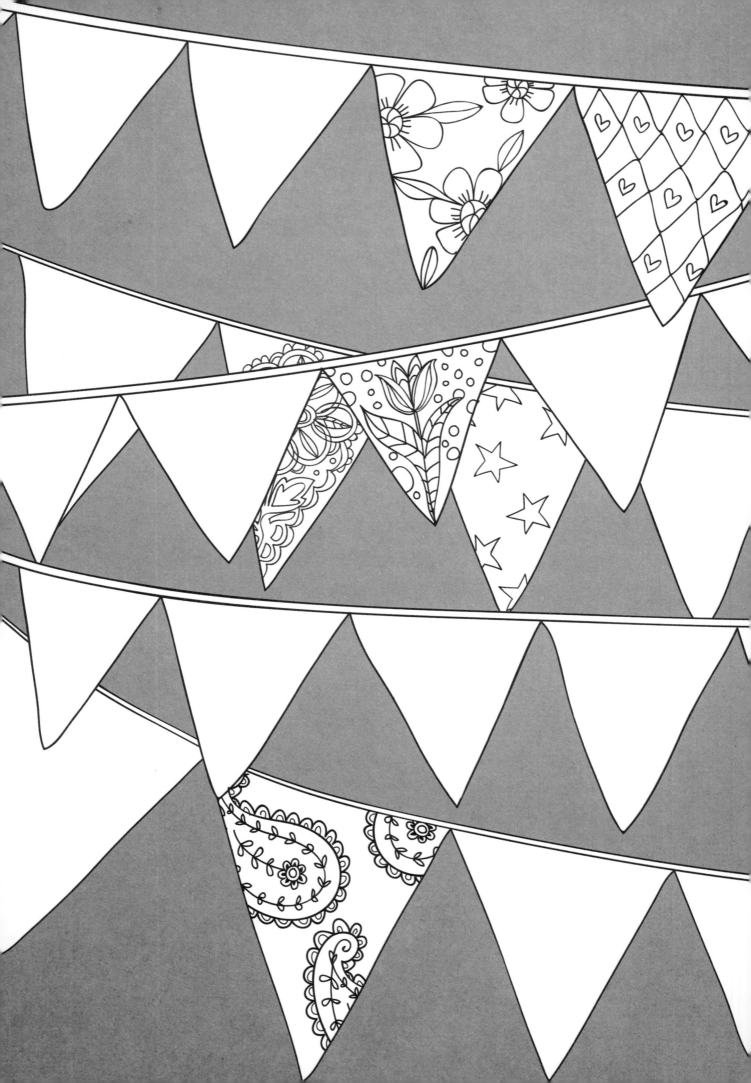

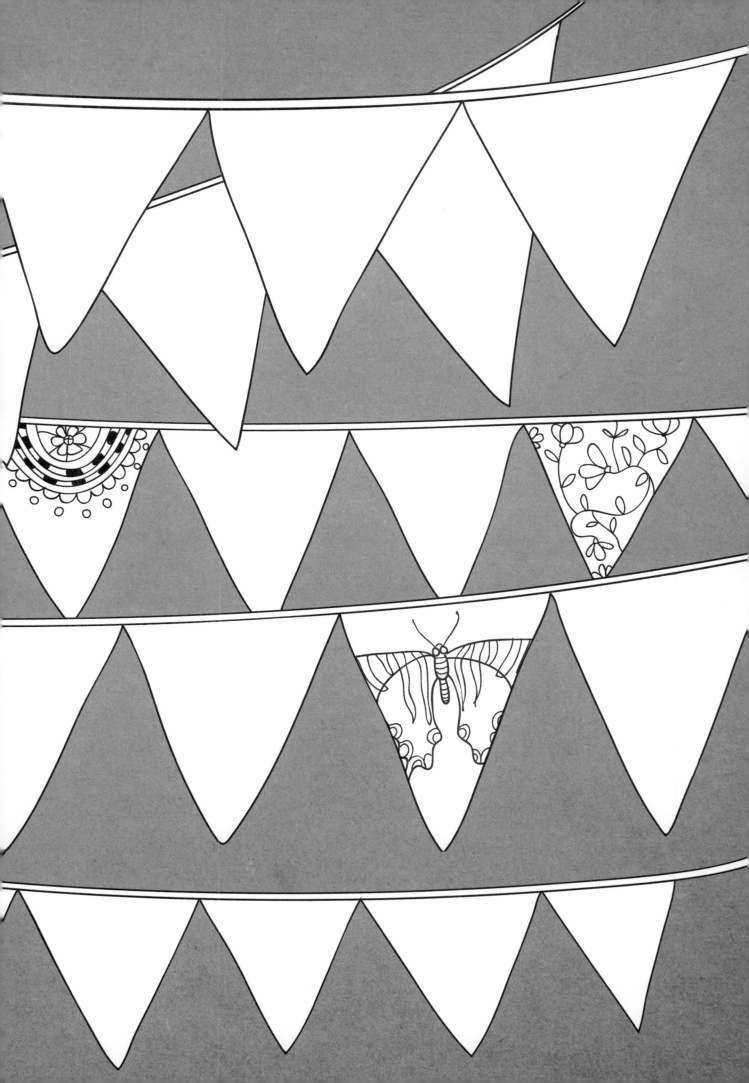

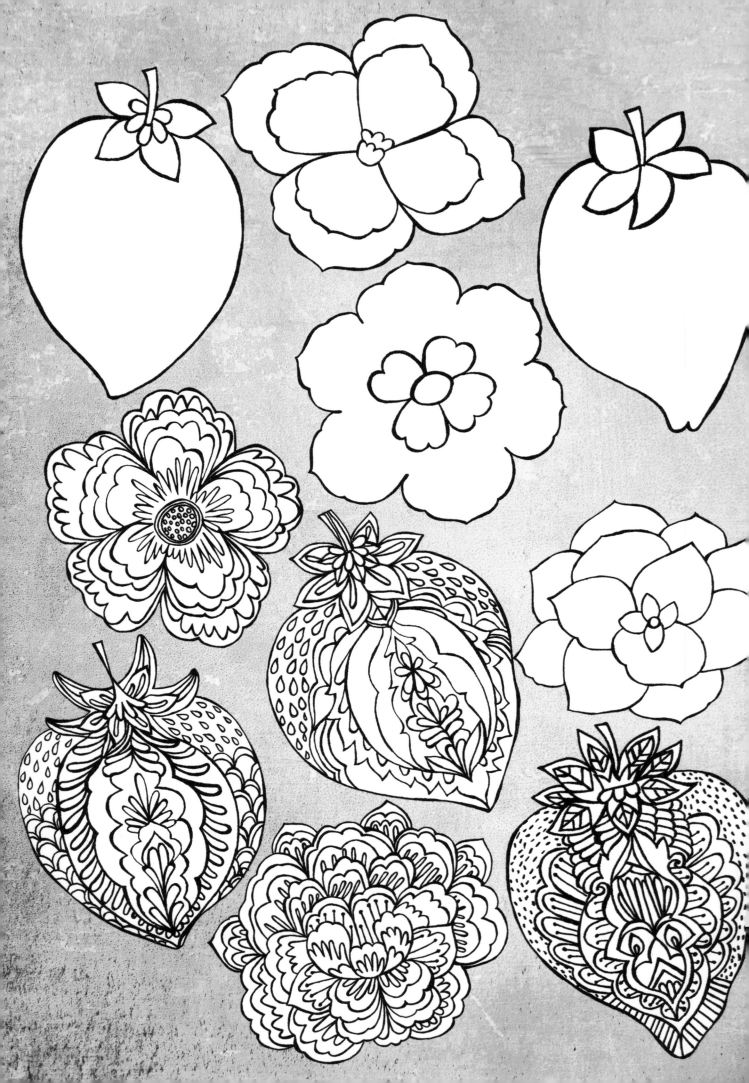

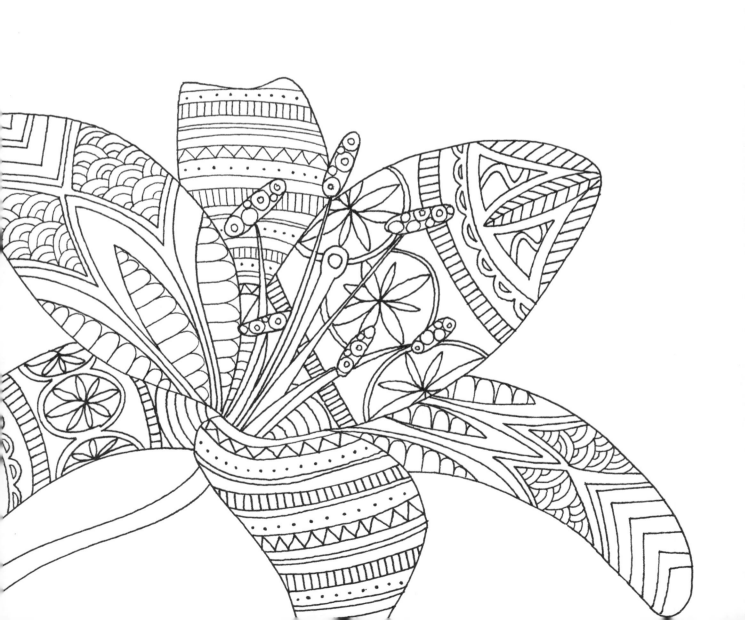

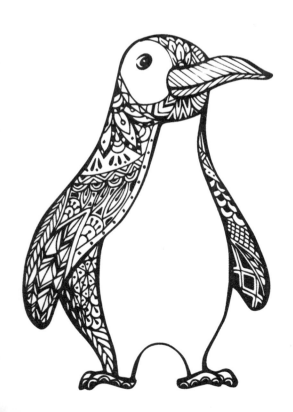

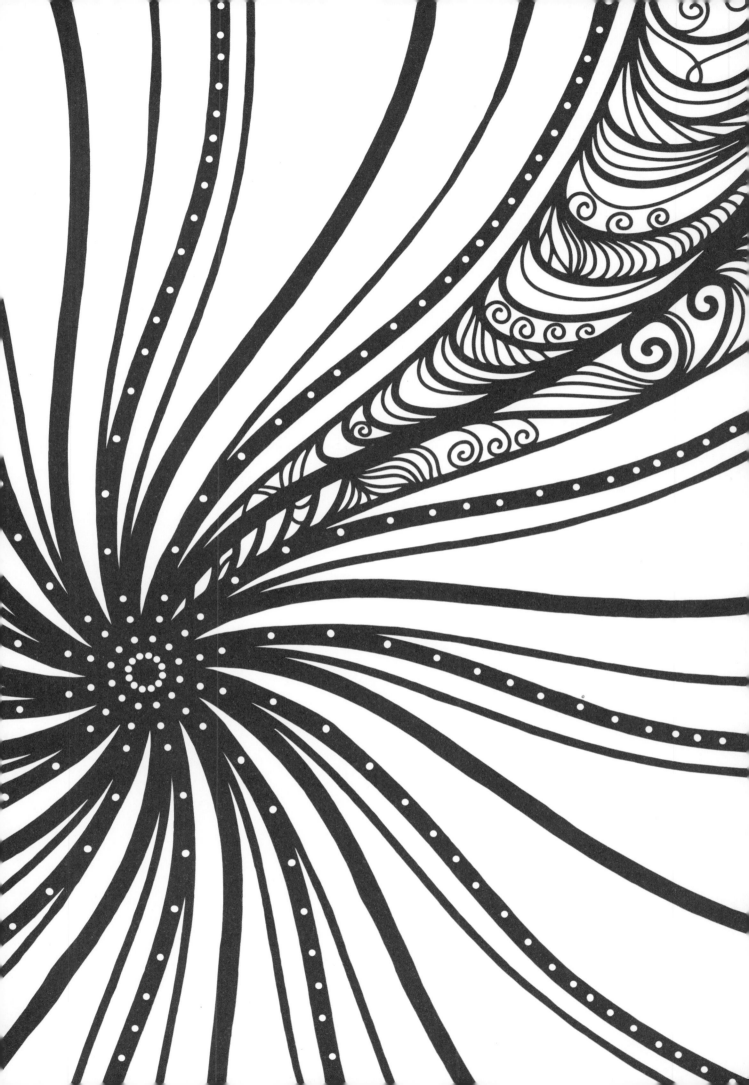

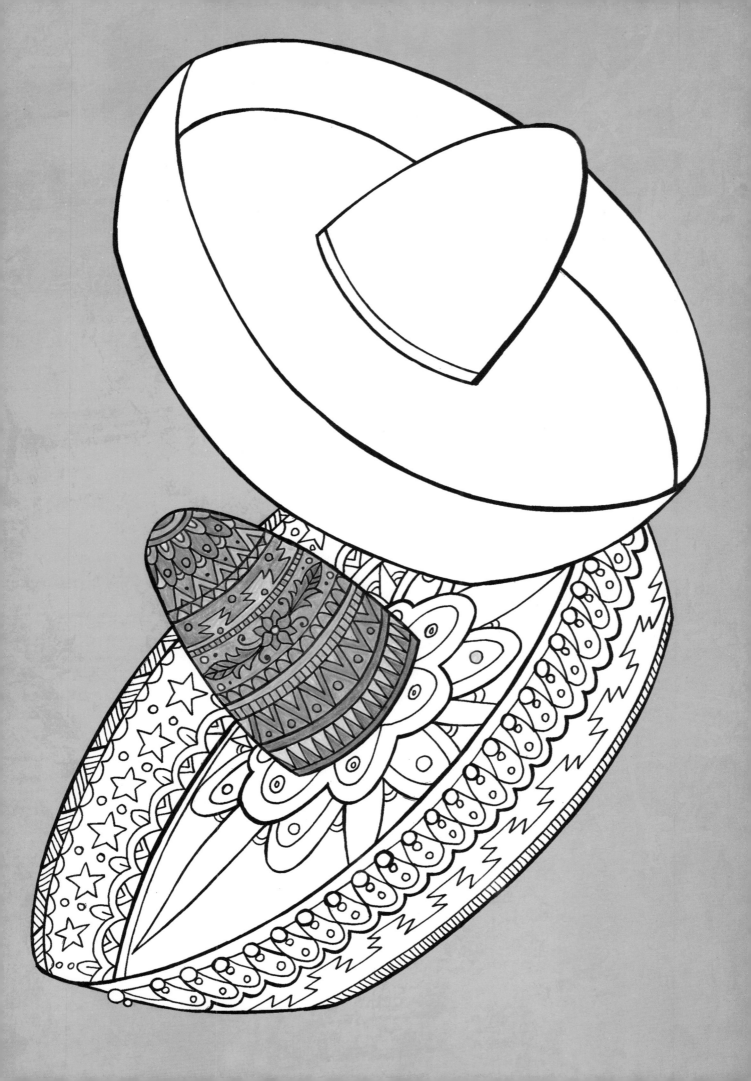

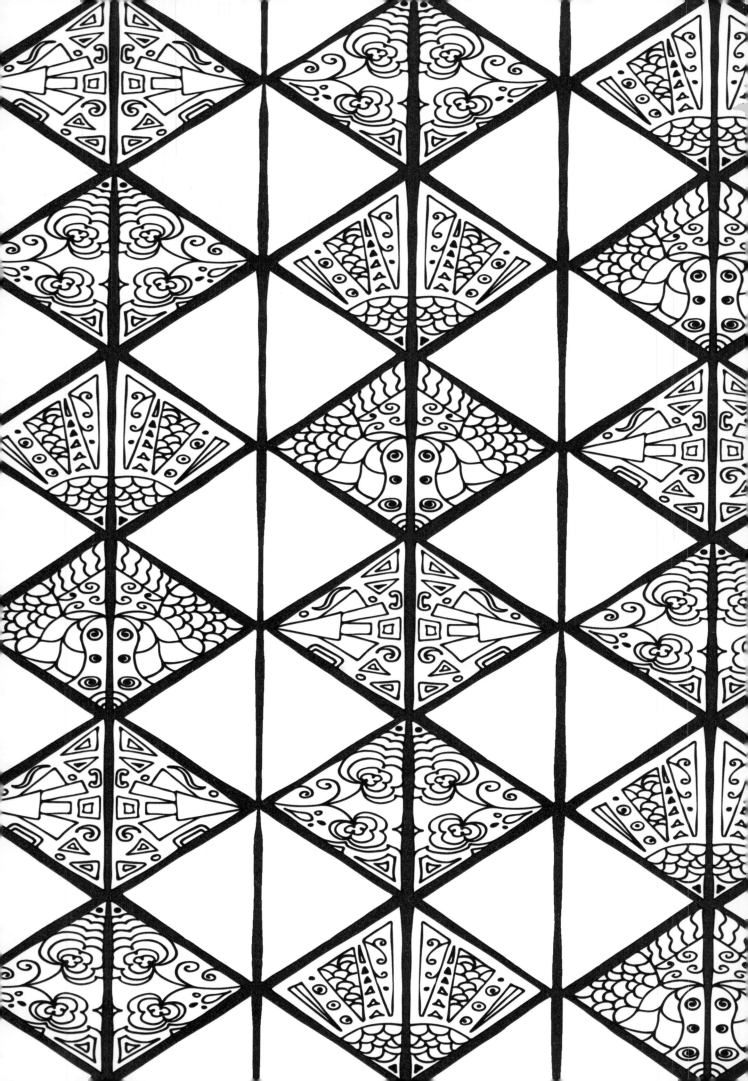

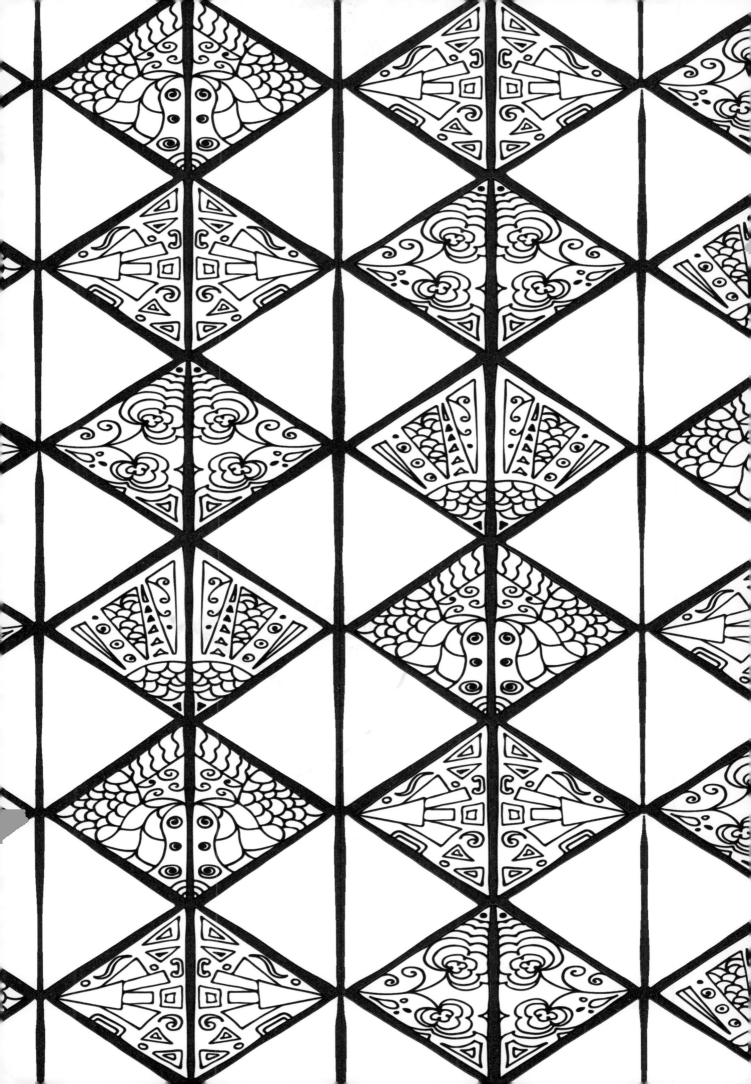

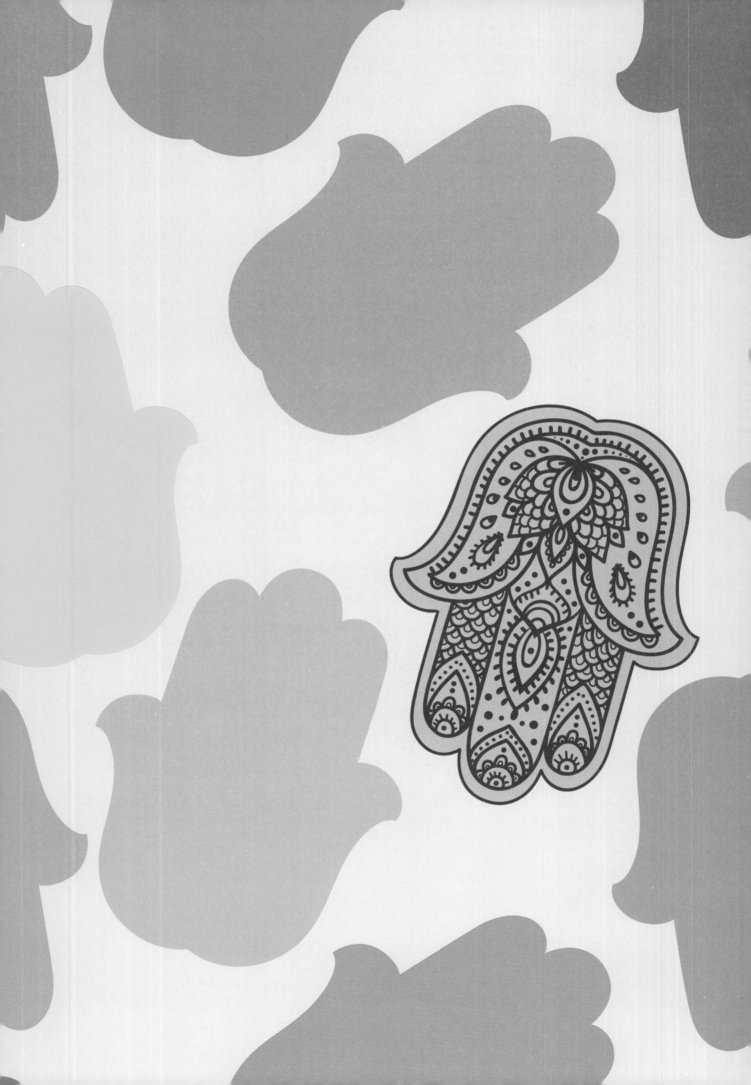

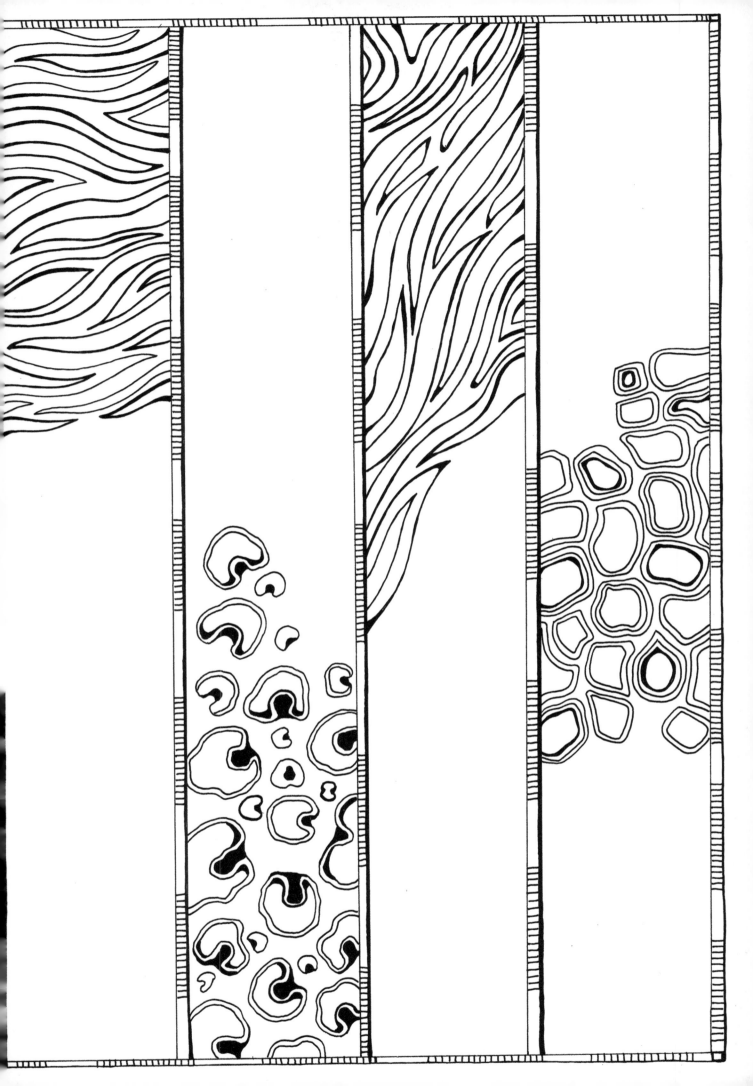

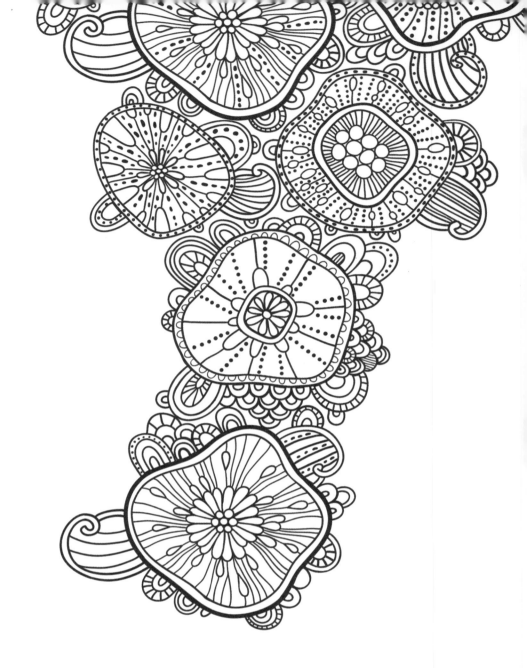

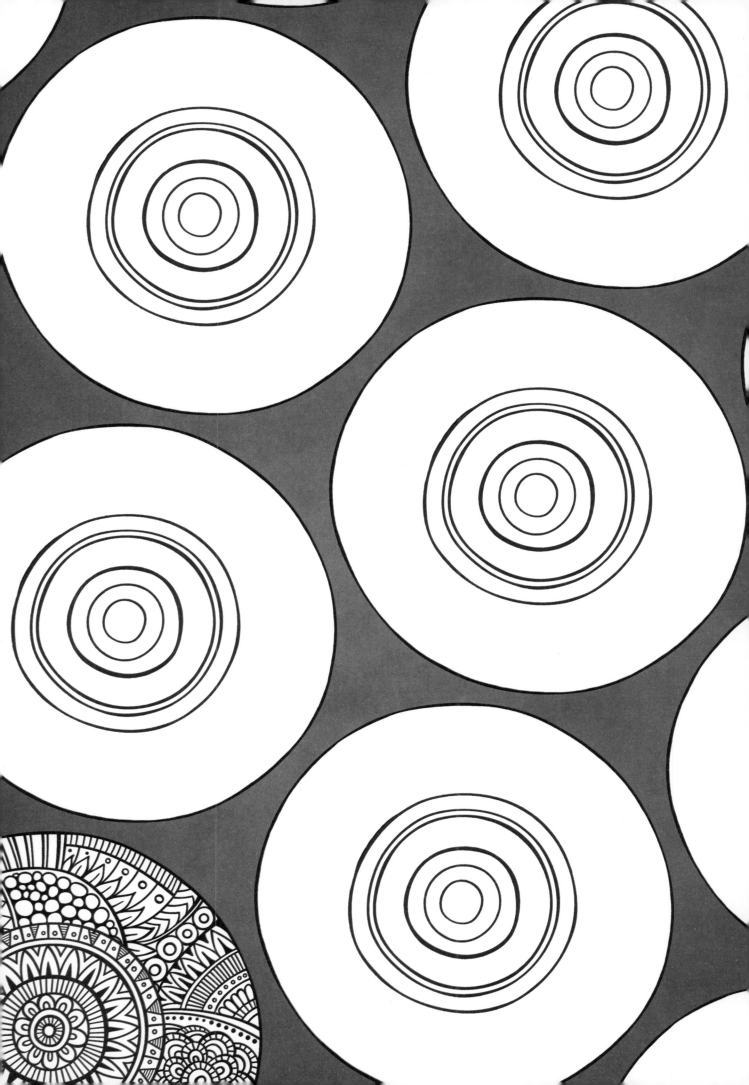

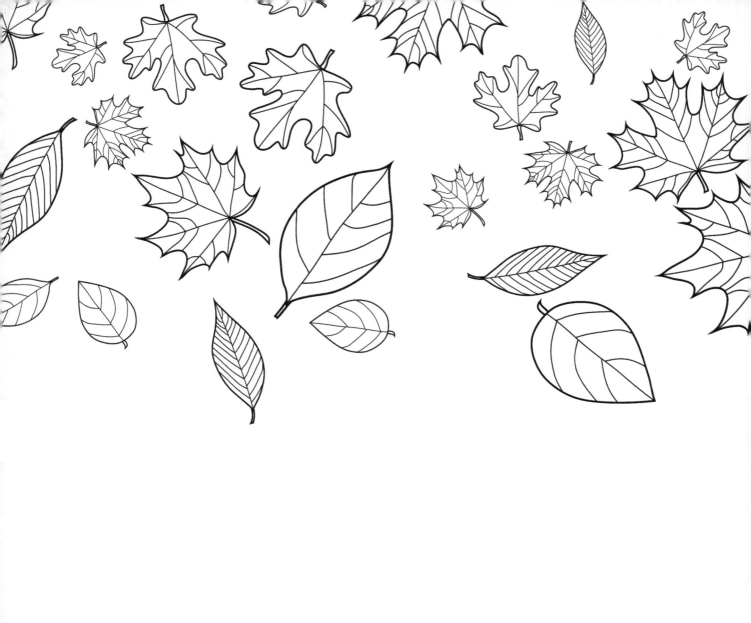

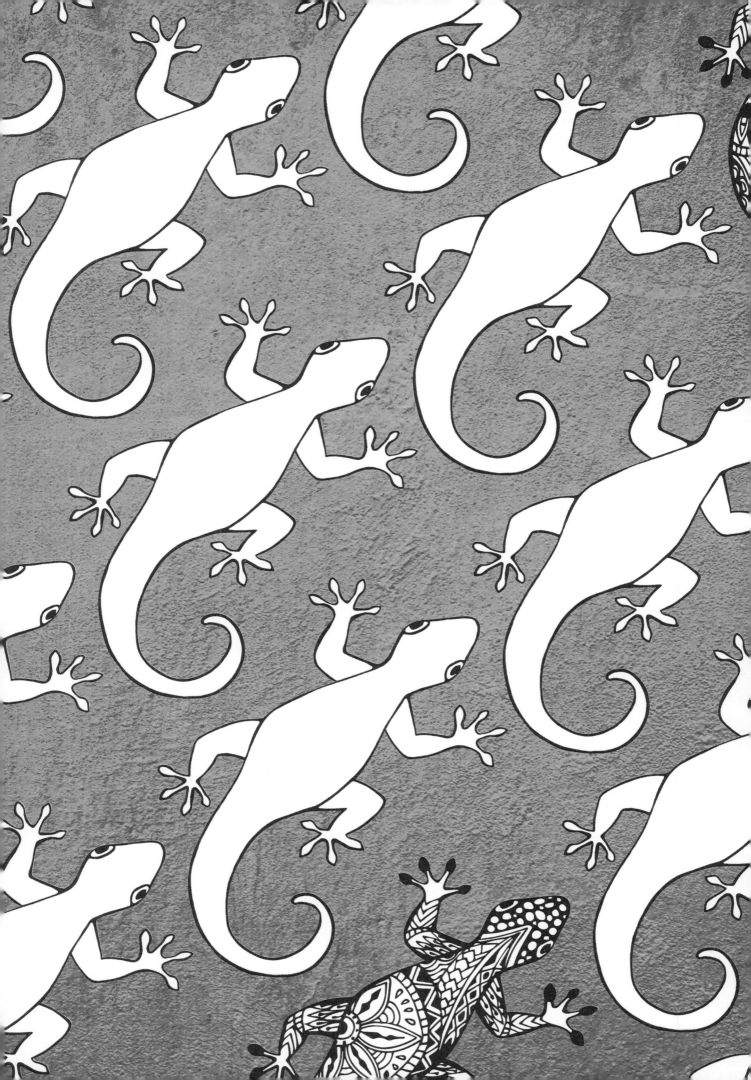

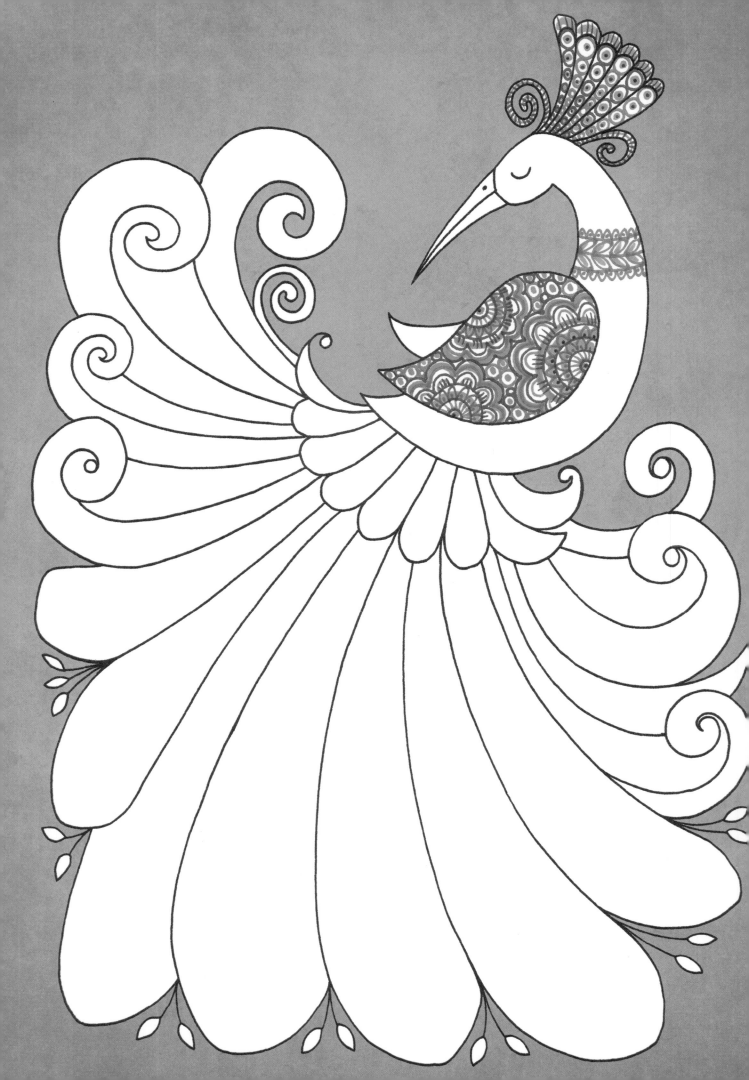